COLLECTING ART
FOR PLEASURE AND PROFIT

"Collecting Art: For Pleasure And Profit" Copyright © 2019 Harvey Manes. All rights reserved. Printed in the United States of America. No part of this book may be used or reproduced in any manner whatsoever without written permission except in the case of brief quotations embodied in critical articles or reviews.

Cover Artwork: Marilyn litho by Andy Warhol
Graphic Design by Cristian S. Aluas

ISBN: 978-0-578-42881-9

"Art is the greatest stimulant of life."
-Friedrich Nietzsche

"Art wipes away from the soul, the dust of everyday life."
-Pablo Picasso

"You never actually own art; you merely take care of it for the next generation."
-Unknown

"The best way to deal with the fleeting nature of time is to create art."
-Unknown

Table of Contents

Foreword ... i

Introduction ... vii

How and Why I Started in Art ... 1

Art Periods and Styles ... 10
 Old Masters ... 12
 Impressionists ... 14
 Modern Art ... 16
 Contemporary Art ... 33
 Pop Art ... 34
 Abstract Art ... 45
 Neo-Pop Artists ... 49
 Graffiti Artists ... 54

Collecting Art by Medium ... 56
 Giclees ... 56
 Posters ... 57
 Lithographs ... 58
 Photography ... 60
 Drawings and Watercolors (works on paper) ... 68
 Paintings ... 68
 Sculptures ... 69
 Conceptual Art ... 75

Investing in Art ... 79
 Things to Consider Before Investing in Art ... 84
 The Most Expensive Paintings Ever Sold ... 86

Art Trends and Branding ... 90

Buying at Auctions ... 95
 Buying in the AfterMarket ... 100

Bidding on the Phone	103
Buying at the End of the Auction Week	104
Bidding in Another Country	104
Celebrity Auctions	107
Cruise Ship Art Auction	108

Buying at Galleries, Fairs, and Charity Events — 110
 Buying at an Art Fair — 112
 Buying at a Charity Event — 115

Buying During a Recession — 117

Death of an Artist — 120

Up and Coming Artists (Who to buy) — 124

Out of Fashion Artists (The art of the deal) — 129

Fraud, Fakes, and Heists — 134
 Art Fakes — 138
 Non-Authorized Works — 141
 Money Laundering Through Art — 141

Ebay and the Online Market — 144

Conclusion — 148

Acknowledgements — 151

Index — 152

Artist or artwork in the book that is not personally owned by Dr. Manes. — 157

FOREWORD

Foreword

Money and masterpieces. The topic that Harvey Manes has tackled in these pages with such wit and wisdom is so utterly fascinating that (like Dr. Manes himself in person) it is nearly irresistible. Even among those in finance who barely understand art, or those in art who haven't a clue about how markets function, this is a sexy puzzle. Probably it is all the more intriguing for those on one side of the equation or the other who cannot quite grasp the nuances of connoisseurship or value. As a journalist (Wall Street reporter as well as auction room correspondent), curator, and observer, I probably have as clear a view as any of this tricky business of art. Yet I know that, without skin in the game monetarily, I am just as reliant on Dr. Manes as any for a lesson in reality, and these pages are full of such lessons.

Art and money has been a hot corner since the wild ride of the auction markets in the 1980s, when international competition and an all-out marketing effort drove prices to record levels. I was an eyewitness to the excitement. As a member of the financial press and then as the editor of the international magazine that covered the art market, I attended the most important auctions and the most talked-about gallery openings of the period. I was there, for instance, in May 1990 when the world record was set at Christie's for Vincent van Gogh's Portrait of Dr. Gachet at $82.5 million. The winning bid came from the back of the room, the steadily upraised arm of a young and then unknown Japanese agent for a billionaire. The place went berserk as the hammer came down. To our astonishment, he was back at Sotheby's the very next night, nearly breaking his own record in the bidding for a major Renoir. That was

only the beginning. I was there just a few months ago when a **Leonardo da Vinci** was at auction at Christie's. Despite some naysayers who wondered about its provenance and its attribution, we were all stunned when it soared to $450 million. The next day I told Harvey Manes to step up the writing on this book, because the need to understand just what drives this market, and what makes a painting that valuable, is clearly pressing.

Harvey Manes is just the man for the job. The appeal of this book is partly the voice of the author. Funny, savvy in a street-smart way, and packed with the intelligence of a "professional" collector, the writing of Dr. Manes is like the man himself (he and I work together on the board of a regional museum on Long Island, where his collection is regularly the source of the highlights for shows that rely heavily on loans). Every page exudes the passion of the committed art lover who is also a generous teacher. Harvey Manes is proud to be an autodidact, and I think that is one of the secrets to his enthusiasm. For many who have ground their way to a doctorate in art history or, worse, curatorial studies, the love of the work of art as object or as expression of the dreams and emotions of an artist is so often hammered into dry, scholarly objectivity. Au contraire, looking at art in the company of Harvey Manes (which is what you are about to do) is never boring.

But here is why this book is important: Plenty of ink has been spilled on the history of art and the more specialized history of the art market. There have been a few entertaining or instructive books, mainly by those in the field (and by that I mean dealers and auction house experts) who are willing to play the role of guide to the labyrinth that is the auction house and gallery scene today. There have also been some lethally dull books on the economics of the art market, generally unable to get past the correlation between real estate or luxury goods and art as commodity. The reason for the proliferation of these books is the boom in the art market. This is an economic sector, as Dr. Manes astutely observes, that has grown astonishingly (almost frighteningly) in the last four decades to a multi-billion dollar, largely unregulated and totally international industry. The need for a forthright and informed book on the art market is clearly dire. Unfortunately, there are few who are in a

FOREWORD

position to write that book.

This is the first book of many I have read and reviewed that comes to the reader with complete honesty as well as authority. The trouble with so many attempts at "explaining" the art market is simply that they are written by someone with too much at stake, usually a dealer or "expert" who has a reason to overplay the safety and downplay the risk of art as investment. Some of these experts have taken a hard-nosed approach to art as an asset class, bullishly insisting upon the upside potential of almost any type of art. Maybe it's conflict of interest, or maybe it's a short-sighted grasp of the vagaries of taste and critical reception, but they are wrong.

Then there are those that insist ("hand-on-my-heart, I swear on my mother's grave" type of insist) that they are in it for the love of art not for the love of money. This kind of hypocrisy can be smelled a mile away, and does the reader who wants straight talk a grave disservice. Art dealers and auction house experts know perfectly well how this dynamic works. I should also add that not all of them are just in it for the dough. I have known many personally who are, without doubt, genuine lovers of art and whose thrill at looking at a painting or sculpture is not feigned. I am unashamed to name a few of them here: Leo Castelli, the legendary dealer who represented Roy Lichtenstein, Jasper Johns, Robert Rauschenberg and so many other epochal figures. The superb auctioneers Christopher Burge (Christie's) and John Marion (Sotheby's), who lit up the room with their enthusiasm and could charm even the seasoned collector with their seemingly endless knowledge of a work of art. I treasure the lessons I learned from them over the years, walking through their galleries as part of the press corps when they were previewing their sales or shows. Burge could "read" a Monet or Degas as eloquently as the great Metropolitan Museum director Philippe de Montebello.

Having enjoyed so many works of art in galleries and auction houses over the years, for free I should add, it might seem pretty hypocritical of me to say that I don't love the monetary aspect of art. That also sounds like a pretty weak statement to introduce a book on the subject. I am ambivalent about the attention that prices receive,

and the ways in which that can divert the perception of the work of art from aesthetics or meaning. But my own hesitancy about the equation between art and money is one reason I can so readily endorse Dr. Manes as an authority. Like a friend who looks out for you rather than as a predator or rival, he offers advice that is straight up and reliable. Like a friend who knows the ropes, more importantly, he offers counsel that is invaluable. Art, and particularly Contemporary art (defined by the auction houses as 1945 and after), is not a game for amateurs. There is an absolute ton of information to factor into the decision to buy or sell a work. Some of course involves the artist and the work itself. That is the part that turns me on the most, frankly, because I love to learn the inside dope on any painting or sculpture that I admire. I also don't mind coming to grips with work that does not appeal to me at first, because I never know what I may be missing. Harvey Manes is a superb tour guide to the beauty, meaning and historical importance of artists and art. I learned so much from reading these pages, including amazing insights into the works of Brueghel, Rembrandt, and Cindy Sherman, artists I thought I knew well (and I have known Cindy since the 1980s). Leave it to a real collector to get inside the art he owns. What is unusual, in my experience, is the generosity and eloquence that make these pages such a treat for the lover of art history. So often the collectors are tongue-tied about what makes a work special, or too fixated on the day-to-day market value, to offer much conversational insight into the piece. Just as a conversation with a committed connoisseur, this book is a genuine delight for those who want to learn more about art. Just turn to the pages on fakes and you will see what I mean.

 But wait, there's more. The information that is necessary to play this game involves more than scholarly research. Like other capital-intensive markets, including the arcane byways of Wall Street that lead into options or futures, the art market is a labyrinth for the uninitiated. Risk and reward are in precarious balance in a sphere where international currencies, nationalism, artistic reputations and the power of collectors or dealers are factors. The bigger this market gets, the more recondite it becomes. Dr. Manes has been in the trenches since the go-go years of the Eighties, and like an experienced analyst of the financial markets, is a brilliant judge of where the trends are heading (judging by the astute

FOREWORD

calls he has made and the collection he has amassed, replete with works by Picasso, Matisse, Dali, Goya, Rodin, Chagall, Giacometti and some of the more advanced Contemporary artists including Damien Hirst and Kenny Scharf, among so many others). The reader of this book is the first to benefit from this kind of experience. Unlike some who jealously guard their maneuvers for fear of being outbid or out-bargained, and unlike (most refreshingly) those who pander advice in return for sales, Dr. Manes serves up a banquet of insights and strategies that you can use to become, well, a top-tier collector like him.

I don't know many people in the art world who would be willing to share this degree - let's call it wealth - of insight so generously and with such a kind intention - to raise the understanding of art and its acquisition on behalf of anyone at any level of experience to the level of a master.

Charles A. Riley II, PhD
New York, March 2018

Charles A. Riley II, PhD is the director of the Nassau County Museum of Art and an internationally recognized authority on the art markets. A curator, author, journalist and educator, his exhibitions at the Nassau County Museum, the Chimei Museum in Taiwan in Berlin, Amsterdam, Manhattan and the East End of Long Island have been widely reviewed and have drawn hundreds of thousands of art lovers. He is the author of 33 books on art and business, including the recently published Free as Gods: How the Jazz Age Reinvented Modernism as well as The Jazz Age in France, Color Codes, Art at Lincoln Center and monographs on Ben Schonzeit, Arthur Carter, Fritz Bultman and Peter Max. As the senior editor of Art & Auction magazine, having written about the art market for Fortune magazine, he has appeared on CNN, CNNfn, NBC, MSNBC, CBS, ABC, and Fox News as a commentator on the art market.

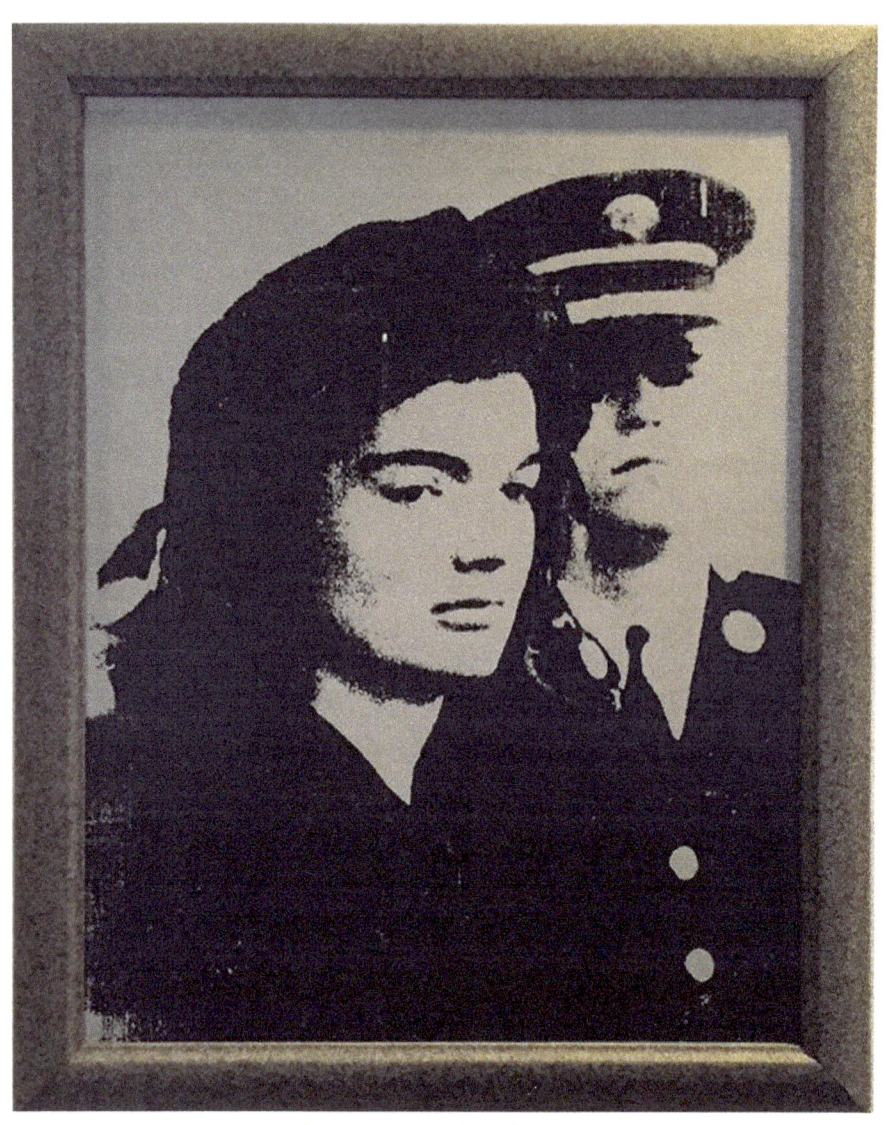

**Jackie with SS Agent
-1964 -Warhol**

INTRODUCTION

Introduction

 I purchased a four-legged jagged metal piece that looks like a dog. The artist, John Chamberlain (1927-2011), was an Ab-Ex artist who used pieces of metal from crushed and dismantled cars. His constructions are quite unique and colorful. Initially, I had it on a coffee table but at 20" x 20" x 15" it was a little too big and overpowering when you sat down on the couch. So I put on the floor next to the couch but felt it was being overlooked. Finally I moved it to a medium-sized pedestal in front of the coffee table, where it is eye-level when you sit down but not too high to bump into when you're walking around. Perfect presentation for admiring it.

 No home should be without an original work of art. Your surroundings say so much about you and invite others to get to know you in a new light. Collecting is not only natural, it can provide a purpose in life. As small children, haven't all of us collected shells at the seashore, smooth stones, bottle caps, baseball cards or dolls? As we get older, we don't lose the urge to collect objects of beauty or curiosity. It just matures with us. As a young boy I collected stamps and coins-and I still have them. I was so proud to show them to my grandson Jacob who recently became interested in collecting stamps. Unfortunately, I didn't collect baseball cards which have skyrocketed in price in the last decade. We are a collecting species looking for hidden treasures. We respond to beauty, creativity and originality. Put these sensibilities together and you have the makings of an art collector. It's a creative act that brings something new into existence—a sense of uniqueness.

It also creates camaraderie. A combination of **work, play and love**, it transforms itself into an elegant way to serve beauty, utility, the self and others.

Why should you collect? That's a question to answer for yourself. Some collect art in the same way they shop, to fill a void or for recreation. Many relish the bidding process at art auctions, for the sake of competition. Others collect art as a financial investment or with the object of growing a valuable collection that can be left as a legacy to family, university or a museum.

I collect because it's exciting. The items I collect express who I am to others. Through art collecting, I also discover things about myself. Artists are thinkers and transmit high concepts about life, existence, ethics, aesthetics and politics in ways that enlighten the audience. Sometimes, simply, the artworks are great conversation pieces that raise important topics for discussion.

It's important that you develop a collection that suits your individual tastes. It's vitally important that you like what you collect since it's an expensive hobby and you usually have to live with the art for years before you can expect to make a profit on the sale. Sometimes you never make a profit and actually lose money. Like stocks, they don't always go up in value.

Ask yourself: What's my goal? Are you interested in simply collecting and never selling, or are you collecting as an investment? Most collectors have both intentions at the same time, which is feasible. A fellow collector once said to me: "You never really own the art; you just have temporary possession of it until it is passed on to your heirs or a museum."

Personally, I have an eclectic eye and enjoy many different areas of art. My collection includes prehistoric fossils, Greek sculpture, pre-Columbian sculpture (from 500 AD), Old Masters, Impressionists, Modern, Contemporary, and some unknown, undiscovered artists who defy these labels.

The art market is a global, under-regulated industry with more than $60 billion in annual sales as of 2018. Even the most experienced collectors often have trouble navigating this opaque and confusing

INTRODUCTION

market. I wrote this book to help illuminate this paradox and share my secrets on how to collect some of the world's most valuable assets.

Whether it's working with dealers or bidding at the biggest auction houses in the world (Christie's and Sotheby's), I will share gems so that you can develop an art collection, or portfolio, that you will be proud of. There are many techniques to bidding. You have to set limits for yourself. I will cover the all-important process of due diligence and, with my law background, I try to offer insights into how to avoid fraud and fakes. I have met some of the most famous contemporary artists over the years and I share those experiences and insights as well.

Some of the important topics covered in this volume include:

-how to evaluate, buy, and sell art while avoiding time-consuming roadblocks and costly mistakes

-how collectors are frequently taken advantage of and actions they should take to protect themselves

-practical tips on how the market works, including galleries, art fairs, auctions, artist studios and online

-how to spot art fraud and fakes

Collecting art is fun and enlightening. Focusing mostly on my first-hand knowledge and real-life stories, this book will teach you how the art market works in practice so you can participate freely and fully with confidence. I would also like this book to open the doors to sharing the collection that I have accumulated over the past 40 years. From the first time I walked into the Brooklyn Museum as a small child, I developed a deep passion for art. Over the course of my lifetime, this early fascination became an obsession. I identified with the artists and the creative process. Although I became a doctor, at heart I feel I am also an artist as well as an art lover. Over the years, I've enjoyed collecting beautiful works and attempted to create art in the studio and in classes. This book, in which I hope to share my passion for art, is entirely based on my own experience.

Dr. Harvey Manes

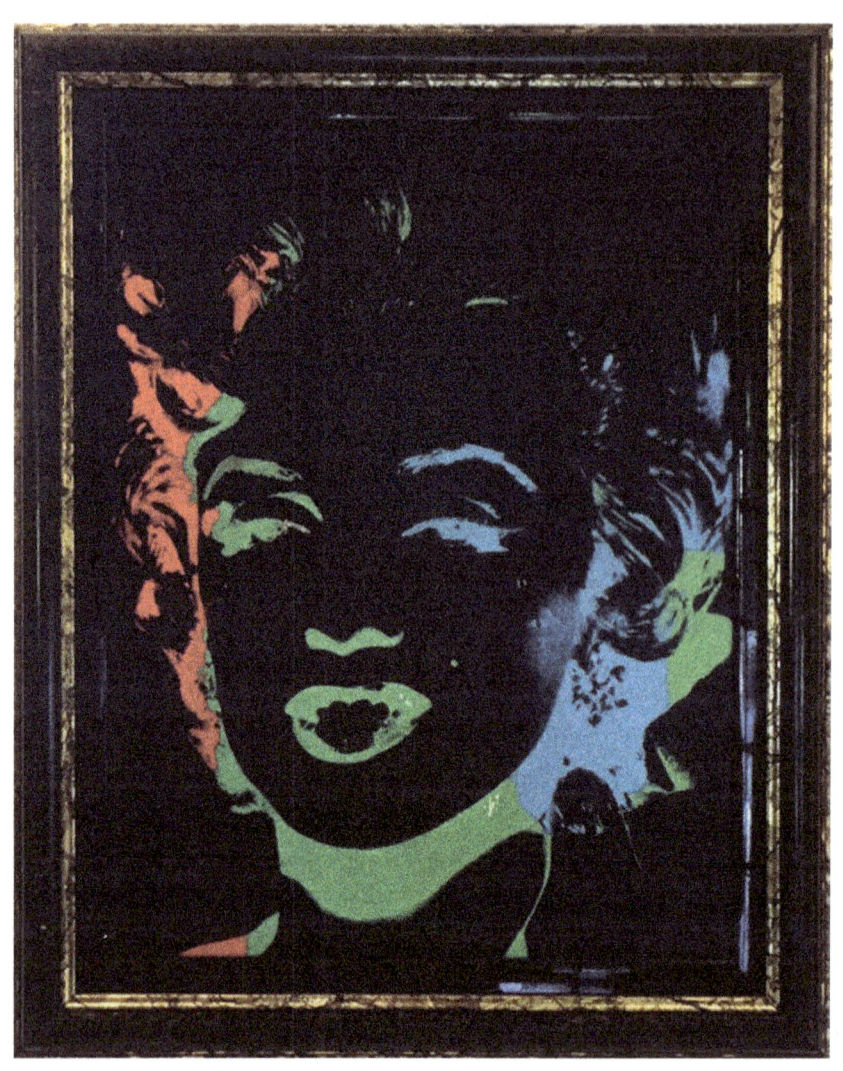

Marilyn Reversal -1976 -Warhol

How and Why I Started In Art

 I was raised in a modest working class section of Brooklyn known as Crown Heights. Museums were occasionally mentioned in school, but never visited. My dad, who arrived from Poland at age 6, had taken violin lessons as a child, as did so many children of Eastern European parents who were determined that their children would learn to play an instrument. Their dream was to discover a child prodigy who would become a famous violinist (it was the era of such stars as Nathan Milstein, Josef Hassid and Mischa Elman). My dad would occasionally take me on a Sunday afternoon to the Brooklyn Museum, where every Sunday there was a violin concert. I absolutely abhorred classical music -rock'n'roll was the order of the day. The squeaking of a violin was no competition for the loud beat of the drums and the vigorous power chords of an amped guitar. However, while I was there, and extremely bored, my attention was diverted to what was hanging on the walls. There were many religious paintings from medieval and early Renaissance times, which I would walk by rapidly, but I was intrigued by the Impressionist paintings that were so colorful, depicting landscapes, seascapes, portraits and street scenes that were dramatically different from what you would see every day on the streets of Brooklyn. Even at that age I realized they were not necessarily realistic like a photograph but were beautiful depictions of life elsewhere. That is how my interest in art began. I was fascinated and transformed into another reality by these paintings. Many times I asked my neighborhood friends to come with me to the museum but they adamantly refused. They had no interest whatsoever. I quickly

realized that my aesthetic interests were not shared by everyone. That did not matter to me. It was definitely their loss.

At Harpur College, I was a pre-med nerd taking science and math and more science. The other courses in the humanities, such as English literature, history and sociology were of no interest to me, except for art history. It was by far my favorite class and I would actually look forward to spending the hour looking at fabulous images and learning the history and meaning behind them. I ended up taking so many art history courses that I could call it a major along with science and math. I recognized how much we learn about the culture, history and the lives of the people of an era through the lens of art. For instance, what was the significance of Michelangelo's Sistine Chapel ceiling or Leonardo da Vinci's *The Last Supper*? Who were the makers of these masterpieces? How were they commissioned, and why were they famous? Why is one artist considered a master and another a failure? There are so many questions to be answered. One of the papers I wrote in college compared the Johannes Vermeer paintings at two major New York museums, the Metropolitan and the Frick.

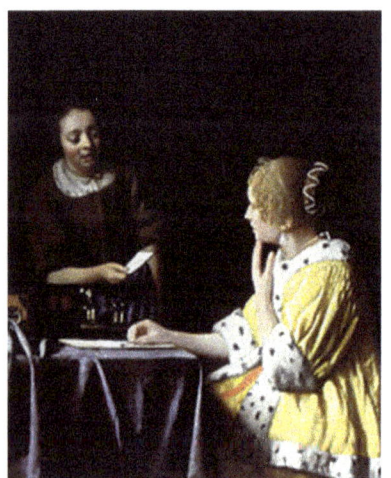

**Mistress and Maid -1668
-Vermeer at the Frick
Collection**

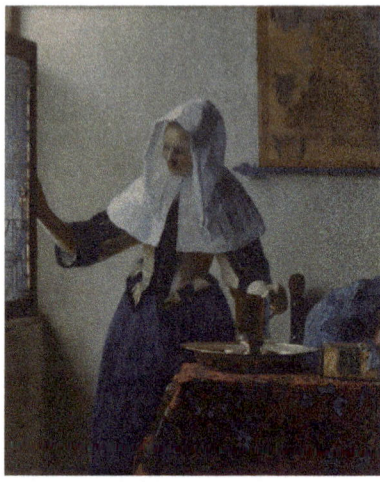

**Woman with Pitcher -1665
-Vermeer at the Metropolitan
Museum of Art**

There was nothing profound or utterly original in the paper but it gave me an opportunity to study his paintings, life and environment

more carefully. Vermeer became one of my favorite artists. He was one of the least prolific of history's celebrated masters. There are only 29 authenticated Vermeers in the world. Luckily the Frick owns three while the Met owns five. The others are in museums around the world. My enthusiasm for the subject showed. In another paper, I compared the French academic painters Greuze and Fragonard. Greuze was a sentimentalist whose allegorical genre painting *Broken Eggs* depicted peasants lamenting eggs that accidentally dropped to the floor. Fragonard painted romantic scenes of young women frolicking in the fields or swinging from garden trees. Each artist reflected the tastes of the time. Although they are both considered masters, their themes were way out of fashion compared to the contemporary tastes. The more I studied art history, the more I wanted to someday have a great collection of world famous art. But how could I pursue my dream without wealth? My parents eked out a modest living while I had saved about $200 in the bank. I had to wait until I became a doctor when hopefully I could afford to start a collection.

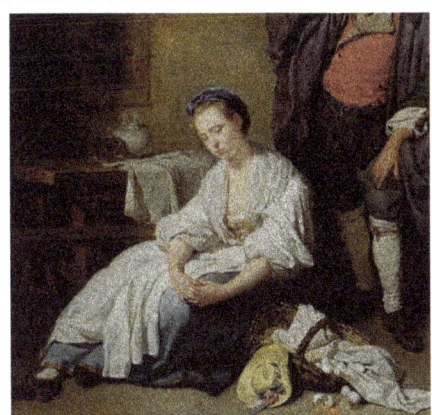
Broken Eggs -1756 -Greuze

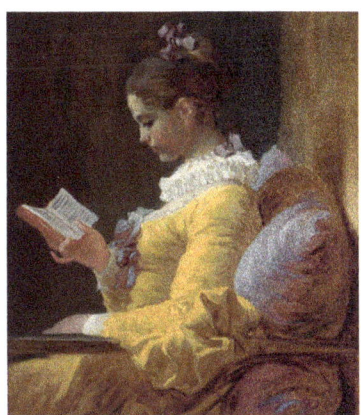
Young Girl Reading -1776 -Fragonard

While a medical student at Downstate Medical School, I continued to visit museums and art galleries in Europe and the U.S. and started to make inexpensive purchases. One of my first buys was a colorful poster by Chagall that I stumbled upon at a local art gallery in Greenwich Village for $100, which at that time was not an unsubstantial amount of money for me.

I was so proud of myself for being the owner of one of the famous masters that I studied about in college. The poster was so beautiful and typical of Chagall but I didn't realize it had negligible resale value. It was purely decorative. In general, posters are published in very large editions, sometimes so large that there is no definitive quantity that can be set on the edition, and because of that they don't increase in value. There are a few exceptions, when a poster becomes very rare and sought-after and is released in a limited edition.

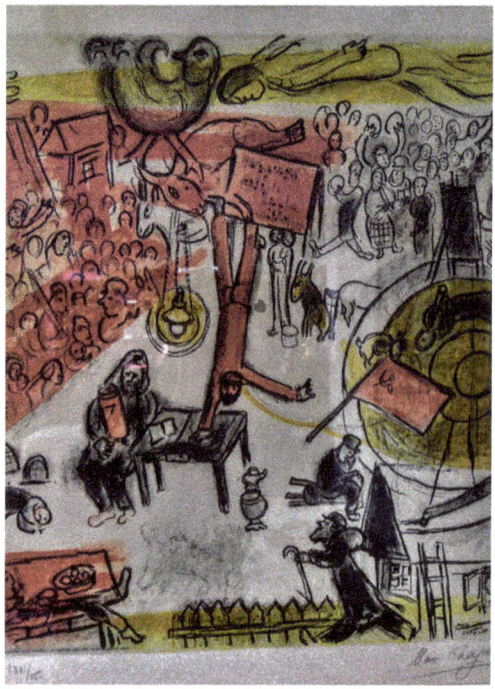

Revolution -1933 -Chagall

I also had a strong desire to create art, especially to sculpt. I started working in clay and made a portrait bust of a fellow student that received many compliments. My first actual sculpting class was at the Brooklyn Museum while I was a resident in orthopedics at nearby Kings County Hospital. I used clay to render the face of the model who posed for the class. Out of 20 students, I was picked to receive a scholarship based on merit. Next I wanted to try my hand in stone, since

HOW AND WHY I STARTED IN ART

"In Love" Limestone **"Reclining Woman" Alabaster**

orthopedic surgery sometimes requires carving bone which is similar in its consistency to stone. I registered for an adult-education course at a local high school. I found a piece of limestone in the art class stone bin and started to chip away with a hammer and chisel and eventually made a copy of an Egyptian pharaoh that I had seen in pictures. Again, it was very well received. I took my next class in stone carving at a local college (LIU) with Alfred Van Loen, a well-known professor and artist. Under his tutelage, I created a number of pieces including pairs of hands, a Centaur, an interpretation of Medusa (which is a classic motif in sculpture, by association with the myth of her turning her admirers to stone) and dozens more pieces in alabaster, marble, onyx, and limestone. My pieces (pictured below), were exhibited in several shows in New York. I really didn't want to sell any of them so I priced the items in the thousands of dollars which was way too high for any item by an unknown artist. Since then, I've created a dozen more sculptures which I proudly display in my homes. A legendary Manhattan art dealer, Mary Boone, once came to see my art collection. As a contemporary art expert, she wasn't there to see my sculptures, but to my surprise she picked out my piece as one of the best in my entire collection.

When I started private practice as an orthopedic surgeon I was able to save some of my earnings to buy luxuries that previously I could never afford. I decided I was going to build my art collection with a big bang. I was drawn to the auction houses by the promise that they were open to anyone, unlike the reputation of the galleries at the time which were restrictive, almost clubby. The two most prominent global auction houses were (and still are) Christie's and Sotheby's. I purchased a catalogue from Sotheby's for an upcoming auction, an Impressionist and Modern art sale in Palm Beach where the rich and famous resided. I carefully leafed through the entire catalogue of around 100 items and found 10 lots I thought were beautiful and in my price range, between $5,000 and $20,000. There were two extremely colorful floral still life paintings in oil by Louis Valtat, an artist I didn't know at the time. Considered a Fauve (a minor figure by comparison with Matisse, the most prominent Fauve) he painted very colorful still lifes, mainly of flowers. I thought his prices would certainly increase since his paintings

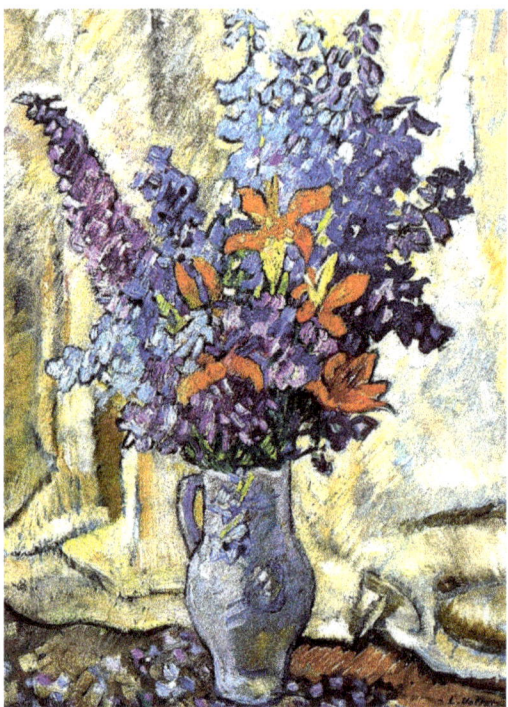

Flowers and Pitcher -1920 -Valtat

are so vivid and unabashedly colorful. I quickly learned that beauty, paradoxically, isn't the only quality that creates demand. Some very unflattering art is valuable while very beautiful art may have minimal value and branded as pretty or "decorative," the kiss of death in some art circles in the 21st century. Several years later, when I became more knowledgeable and sophisticated in my tastes, I decided to sell the two Valtat paintings, since he was mainly a decorative artist and I felt his paintings weren't edgy enough. I would rather use the money of the sale (I sold for a slight profit) to buy other art. I still have a soft spot in my heart for Valtat but his prices have barely increased in the past 40 years. As a self-taught collector, I ask questions of dealers, experts and advisors to learn to buy pieces which have a better chance of increasing in value, although I follow my heart.

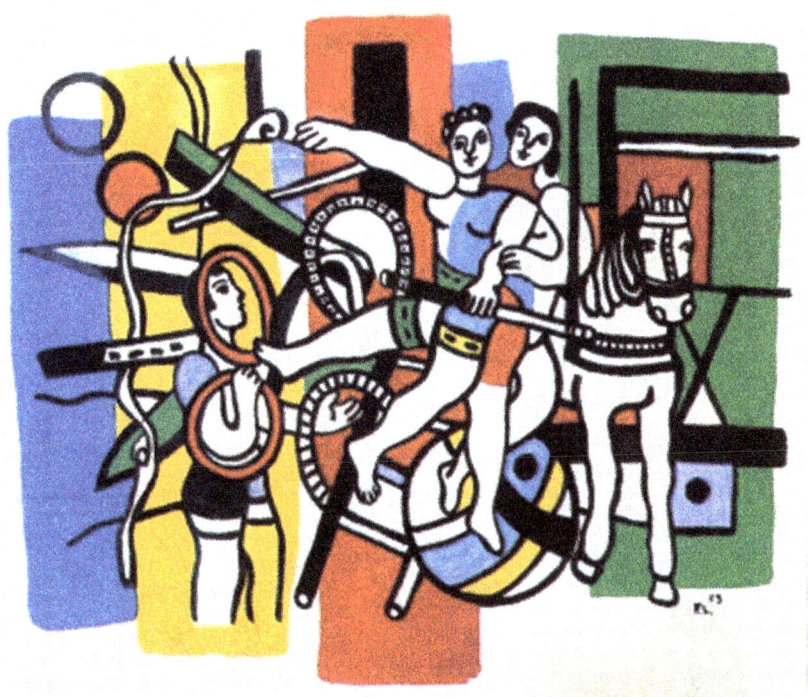

Les Trapezestes -1953 -Leger

I also purchased, for $16,000, a fabulous gouache circus scene by Fernand Leger, whose name I knew from my college art history classes as the friendly rival to Picasso in Paris, and an enormously influential

Modernist who shaped the course of American art history as a teacher of many New York artists. This turned out to be a great investment. I really hit the jackpot since the value of the piece has increased twentyfold since then.

Another piece was a lovely Picasso linocut lithograph of one of his wives, Jacqueline Roque, nicknamed *Bright Eyes* for obvious reasons. Little did I know that his linocuts (made from linoleum) were very sought after and still are considered to be among his most important prints. At $10,000, it was a great investment and has increased in value more than tenfold.

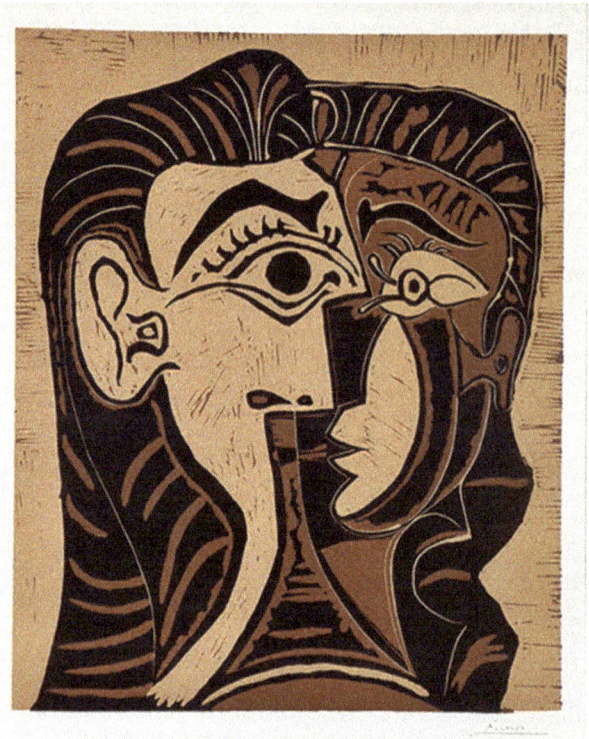

Tete de Femme -1962 -Picasso

Lastly, I successfully bid on a lithograph of a colorful mythological scene (*Daphnis and Chloe*) by Chagall. Eventually I sold this piece for a small profit. Chagall had foolishly flooded the market with lithos, so the prices never increased. Scarcity counts big time.

Several other artists, including Peter Max and even the Catalan master Joan Miro, have ruined their markets with excess inventory. The law of supply and demand applies and as a result their prices don't increase.

In an attempt to create an instant art collection, without seeking professional help, I sent in my bids via the mail to the Palm Beach Sotheby's branch and used a simple mathematical formula that I developed to decide how much to bid. This is an excellent opportunity to go over some of the basics of bidding at auction. Each lot in a catalogue is provided by the specialist in the department (in this case, Impressionist and Modern) with low and high estimated prices reflecting a range of values that the house expert believes the paintings are worth.

Let's say the Chagall was estimated between $10,000 and $15,000. Since I believed there would be many buyers who would just put their bids at the exact low estimate, I added 10% above it. I felt, by raising the low estimate by 10%, I had a better chance to be successful and still get a reasonable price. My method was unconventional, and I was an unknown contestant in the competition and got a call from Sotheby's when they received my mail-in bids and began to question me. I didn't have an account and was a complete stranger to them. They asked me why I submitted bids for ten items and wanted to verify that I had the funds to pay for them if I was indeed the highest bidder. Although I was surprised, I didn't blame them for asking, since I was never a client and they didn't know me from a hole in the wall. If I was successful on all ten items, I was on the hook for about $250,000, which in 1978 was my entire savings. I answered them in the affirmative but I did ask them what would happen if I didn't pay for them at all. They informed me that the artwork would be auctioned again at the next available auction, that I would be responsible for paying the commissions on the buying side and on the selling side, and there was no guarantee the items would sell for the same amount that I had paid. That sounded reasonable to me. Although I was taking a risk, I could just resell them.

Sotheby's called the next day after the auction to tell me my bid was successful on five items—for a total of $100,000. At first I panicked. At that time, I had recently purchased my house for $100,000, a lot of money for me. Then I became elated that I was successful. My formula worked, and I had my first collection of art (even though it was

only five items—the Chagall, Picasso, Leger and two Valtats). It took several days for the items to be shipped to Sotheby's in Manhattan. With tremendous anticipation and excitement racing throughout my body, I drove into the city to pay for and pick up my art collection. Mind you, I hadn't seen the paintings in person as yet. I gave the bank check to the cashiers and the art handlers brought out the paintings. It was a good thing that I was standing, otherwise I would have fallen off my seat. The items were way beyond beautiful! I was thrilled! The staff at Sotheby's congratulated me, the rookie collector who had snared such bargains. I was so proud.

Since that moment I've added more than one hundred new pieces to my collection. I buy new art for many different reasons, most important is that I really love the piece. It has to be representative of the artist. If an artist is famous for painting balloons, you're not going to buy a painting of bicycles. I like to get a bargain basement price, so when possible, I try not to pay more than I think a piece is worth. However, if I really, really want an item and don't want it to get away from me, I will pay a dear price. Most of the time, I try to pay what I believe to be a reasonable price. I always do my research, which is much easier now since the advent of the internet. I also sign up for apps like Artnet, which has a record of all the auction prices for an artist. I research the previous prices paid at Christie's and Sotheby's as well as Bonhams, Doyle's, the Hotel Drouot, and the new auction houses that have proliferated in Asia. If the price isn't reasonable, I will usually pass on the piece. I've found there is always another piece for sale in the future. But I have to admit that on occasion I let my emotions get the best of me; after all, it is a passion.

Imagine owning a beautiful Rembrandt or Rubens. Or a similar 15th century artist that I own, an Albrecht Dürer, the painter and printmaker of the German Renaissance. These pieces are rare and invaluable. Priceless. Thank goodness that sometimes they do come on the market and have starting bids attached to them. The key is to choose wisely.

HOW AND WHY I STARTED IN ART

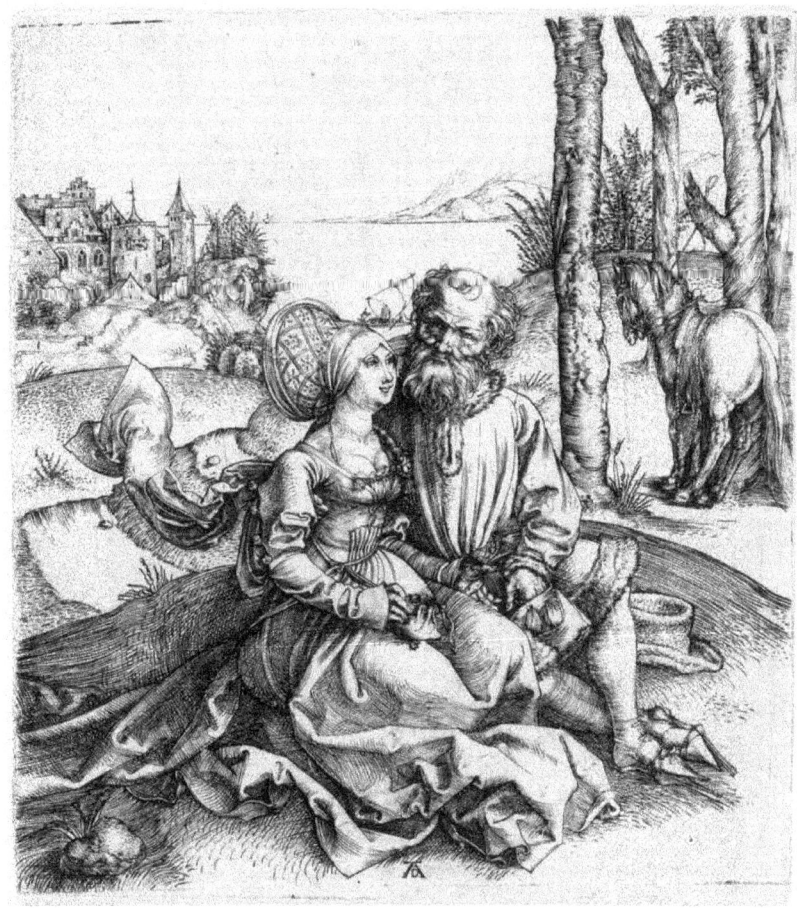

The Promise of Love -1504 -Dürer

Art Periods and Styles

Some collectors select art based on periods or styles, such as "Old Masters" (from the early Renaissance through Rembrandt or Rubens to the realists of the nineteenth century) while others prefer the "Impressionists," such as Renoir and Monet, or the "Modernists" such as Picasso and Chagall. Still others prefer "Contemporary" artists such as Damien Hirst, Jeff Koons and Cindy Sherman. There are many subdivisions in each category. Some collectors decide to collect one particular artist and not necessarily a school of art, such as the "Abstract-Expressionist" artists like Pollock and de Kooning, while others will shun those artists for the "Pop" artists, like Warhol and Lichtenstein. Another category which attracts many collectors is up-and-coming or "Emerging" artists.

When investing in art, it's important to note that works by Old Masters like Rembrandt do not increase in value as rapidly as Modern and Contemporary Art. Although a Rembrandt is still a solid investment and the price of the piece will increase, albeit more slowly. Notably, with Modern and Contemporary Art, people's opinion of an artist's work can change quickly, and the value is more volatile, especially if they haven't had a recent show at an important gallery or museum. In the contemporary market, an artist could be hot one year and cold the next, what Wall Street would call a "high flying stock." The Old Masters tend to act like stocks in the Dow (GE, IBM), slow and steady growth.

Trends change in the way we buy art. The type of art that was once popular may not be as popular today, and the older an artwork

gets, the harder it becomes to purchase, like da Vinci's or Raphael's. Only museums, large corporations or billionaires can afford them. The multimillion dollar paintings of today may be absolutely priceless, like the Mona Lisa. In the meantime, what great fortune it is to be able to afford other enchanting artworks in our lifetime and enjoy them in the privacy of our homes.

There are many reasons why certain artists increase in value while others who are more talented do not. Not because one artist has more talent or uses color in a better way, but because of **branding**. Granted, talent and intellect have been proven by sociologists to influence an individual's success. But strategic branding adds personality, distinctiveness, and value to a product or service. As we say in the world of art collecting, "buy with your ears, not with your eyes."

Art is subjective, particularly Contemporary Art. Branding connects an artist with a high-level dealer. If the artist is represented by a high-level dealer such as Gagosian, (or in the past, Castelli), the artist has a much better chance of becoming important. The dealer has connections with collectors and museums that have lots of money. All the dealer has to do is make a phone call and let them know that the collector needs to have a piece by a particular artist and the deal is done. I like to do my own research but many collectors don't have the time and rely on dealers' opinions, like a stock adviser. The dealer is a facilitator for both parties, the artist and the collector. For living and active artists, these dealers have connections to the auction houses and make deals with them to present their artist at the most high-profile auctions among other important artists. The auction houses give high estimates and negotiate a minimum price even if the item doesn't sell. The dealer also negotiates terms with museums and promises to donate a piece or reduce the price for a piece if the museum is interested in the artist. By having a presence in museums and having the auction houses sell their art, the prices eventually go up, sometimes very quickly. The collector gets bragging rights by saying they bought a piece from Castelli or from Sotheby's. It becomes a virtual cycle. Branding in Contemporary Art can substitute for critical judgment. No one is rushing to admit that they neither understand nor like what is being shown.

Plan on owning a painting for several years before you would consider re-introducing it onto the market in the hopes of making a profit. When buying from an auction house, you pay a 25% commission on buying and 10% on selling, therefore you need to make at least 35% profit on reselling. Based on those upfront costs, you need to hold the piece for a few years. Plus one of the most thrilling parts of art collecting is to get a piece at a great value and watch the artist's demand grow over the years, raising the monetary value of your purchase and your collection.

Old Masters

The term "Old Masters" refers to the recognized European artists working between the early Renaissance (the 1300s) and the mid-1800s. Most people, even with the most modest education, will recognize several names, such as da Vinci, Michelangelo and Rembrandt. Most collectors, including myself, usually don't collect from this period because they believe the prices are too high, because of questions regarding authorship, or because we don't completely appreciate these works of art. We've become accustomed to expressionist or non-representational art. In the early days of collecting, I preferred more modern-looking art. As I mature I've come to appreciate the Old Masters, and they can be acquired at surprisingly reasonable prices. In general, this category is undervalued, especially when compared to the prices of contemporary artists whose work has only been on the market for a few decades. For instance, a Basquiat oil may be priced between 10 million and 100 million dollars while an oil painting by Pieter Brueghel, which is far scarcer, would be valued between 2 million and 10 million.

In the "Old Masters" part of my collection, I own several Rembrandt etchings, a Brueghel oil painting, and a fabulous oil by El Greco. This category's prices can get very high for the very highest quality oil paintings, while etchings, as multiples and works on paper, are less expensive. I recently purchased two Rembrandt etchings for a measly $20,000 each (obviously I couldn't afford an oil for $20 million).

ART PERIODS AND STYLES

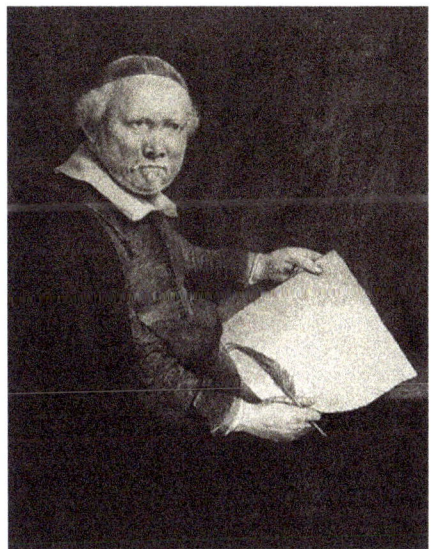

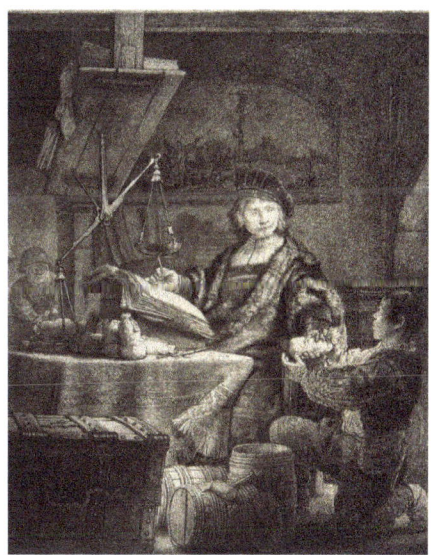

**The Writing Master -1658
-Rembrandt**

**The Gold Weigher -1639
-Rembrandt**

There are several reasons I purchased a Rembrandt.

Since he is considered one of the greatest artists that ever lived, I felt my art collection would be incomplete without a work by this master.

I was influenced by the fact he was considered a rebel during his time. He was the first artist who painted realistic portraits which included all the lines and defects on the subject's face. He didn't idealize his subjects like other artists who preceded him. He was the first painter to use chiaroscuro (the stark contrast of light and shadow) which highlighted areas to create a more dramatic effect. The two etchings I was able to purchase were from 1639 and 1642 and fully represent his style.

My collection also includes a painting by Pieter Brueghel the Younger, from 1621, called the *Bird Trap*, and an El Greco entitled *St. Francis and Brother Leo Contemplating Death*. These paintings will be further discussed in the chapter "Buying at Auctions."

Impressionists

The period between 1860 and 1910 was a time during which artists broke away from realism and created art that suggested reality. The public, at first hostile, gradually came to appreciate this bold group of artists who had captured a fresh and original vision of both art and nature. Now household names, the group is widely liked even by novice art appreciators. Renoir, Monet, Pissarro and Toulouse-Lautrec are some of the more prominent examples.

I was raised in a modest working-class section of Brooklyn known as Crown Heights. Museums were occasionally mentioned in school, but never visited. My dad, who arrived from Poland at age 6, would occasionally take me to the Brooklyn Museum, where every Sunday afternoon there was a violin concert. My dad had taken violin lessons as a child, and like many Eastern European parents whose dream it was to discover a child prodigy who would become a famous violinist—this was the era of stars like Nathan Milstein, Josef Hassid and Mischa Elman—determined that his son would learn an instrument. This was the era of stars like Nathan Milstein, Josef Hassid and Mischa Elman. I absolutely abhorred classical music—rock 'n' roll was the order of the day. The squeaking of a violin was no competition for the loud beat of the drums and vigorous power chords of an amped guitar. However, while I was there, and extremely bored, my attention was drawn to what was hanging on the walls. There were many religious paintings from medieval times and early Renaissance, which I walked by rapidly, but I was intrigued by the colorful Impressionist paintings: the landscapes, seascapes, portraits and street scenes that were dramatically different from what I saw every day on the streets of Brooklyn. They weren't realistic like a photograph but were beautiful depictions of life elsewhere. That is how my interest in art began. I was fascinated and transformed into another reality by these paintings. Many times I asked my neighborhood friends to come with me to the museum but they adamantly refused. They had no interest whatsoever. I quickly realized my aesthetic interests weren't shared by everyone but that didn't matter to me. It was their loss.

My collection includes several Renoirs, a Pissarro oil painting, and a ceramic painting by Toulouse-Lautrec. Many novice collectors love this category. They relate to the beautiful colors and design, as opposed to the more conservative realism of the Old Masters or the wild stuff that is prevalent in the Contemporary category, both of which are more difficult to appreciate.

When I first started collecting, I desperately wanted to own a Renoir, whom I had studied in art history class at Harpur College and was convinced that he was one the greatest artists. His colors and figures were so beautiful that they were ethereal. Eventually I purchased an oil painting, followed by a sanguine drawing, and finally a lithograph. All three pieces are lovely but as my taste matured I found them to be too "sentimental." Although a high-quality Renoir oil painting could sell for millions of dollars, a collector can obtain a smaller lesser-quality oil for several hundred thousand and a litho for several thousand. Art tastes have moved on just in the past few decades, and the Impressionists have fallen from the top tier of the market and become less desirable, especially compared to Contemporary Art.

Several years into my collecting, an affordable Pissarro oil painting of a landscape scene came up at auction. Pissarro is considered by

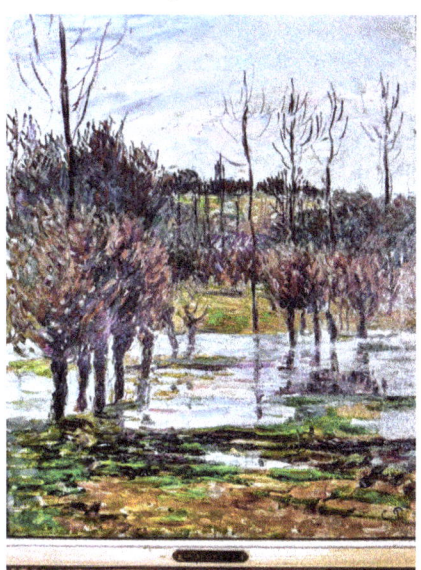

Landscape -1895 -Pissarro

many to be the "father of Impressionism," so I felt having a piece by him would be an important addition to my collection.

The Jewish Museum asked to borrow the painting for a Pissarro exhibit. It was considered by many to be one of the best paintings in the show because of its vibrant colors and depicted Pissarro at his best.

I also own a rare ceramic painting, from 1893, by another well-known Impressionist, Toulouse-Lautrec. He was primarily known for his posters that depict scenes from the Moulin Rouge in Paris, and painted only one set of ceramics. The piece is beautiful and very unique. It even has an inscription by the model written to the artist. The painting is depicted later in the book. In "Buying at Auctions."

Modern Art

There is no exact time when Modern Art began. Many experts would consider Cezanne as the "father of Modern Art" but it would be safe to say it started in the late 1800s and early 1900s when artists broke away from the tradition of depicting realism and experimented with ideas that tended towards abstraction. There are many sub-categories in Modernism, including Post-Impressionism (van Gogh, Gauguin), Cubism (Picasso, Braque), Fauvism (Matisse, Vlaminck, Derain), Dada (Duchamp, Man Ray), Surrealism (Dali, Magritte), Non-objective abstraction (Mondrian, Kandinsky), Expressionism (Schiele, Klimt, Munch) and others. My collection includes works by many famous modern artists such as Picasso, Chagall, Leger, Dali, Miro, de Chirico and Giacometti.

Pablo Picasso (1881-1973), of course, is at the top of the list. Everybody knows his story and his myth. He was the co-founder with Georges Braque of the Cubist movement, known for his masterpieces *Les Demoiselles d'Avignon* (1907) and *Guernica* (1937). According to the Guinness Book of Records, Picasso was the world's most prolific professional artist with an estimated production of "13,500 paintings and designs, 100,000 prints and engravings, 34,000 book illustrations and 300 sculptures and ceramics." Unlike most artists of his prominence, the sheer quantity of his output has defied complete cataloguing, and

there is no agreed-upon reference work that lists all of his paintings, sculpture, drawings, prints and ceramics. He flooded the market with his work. However, he was so influential to so many other artists that his legacy has prevailed and his museum artworks, like his *Les Demoiselles d'Avignon* at the MoMA in New York, are still a major draw for tourists. Some of his artworks, like the *Dove of Peace* and his *The Old Guitarist* from his blue period, are iconic. His oeuvre is roughly estimated to be valued at over $800 million and certainly his work has gone for very high sums at auctions.

Dove of Peace -Picasso

Through the years I have acquired many pieces by Picasso. One of my favorites is a watercolor/gouache that was a Christmas present (dated Dec. 25, 1943) given to Marie-Therese Walter, of two figures on a bench kissing each other, probably representing him and a lover. In 1936, Picasso already had moved on to his new paramour Dora Maar but must have still had affection for Marie-Therese who bore him a daughter named Maya.

Another interesting piece I purchased is a portrait of Jacqueline (the second wife and muse) that was done in crayon. It was the first art work by Picasso that I purchased. I remember the dealer trying to persuade me not to buy it because it was just a crayon drawing. But I liked its childlike quality that Picasso is famous for, so I bought it in spite of her negative comment.

I was a sucker for Picasso and came across one of his harlequin

Couple sur un Banc -1943 -Picasso **Jacqueline -1958 -Picasso**

Compotier -1920 -Picasso

paintings from earlier in his career (1920) and decided it would be another great addition to my collection. You can never too many Picassos.

Actually there are many graphic erotic drawings by him that I could easily live without. Picasso also created numerous ceramic vases and plates. Most of them are very typical of his style and can be purchased

for a reasonable price, usually several thousand dollars. I have acquired a half dozen vases, and I absolutely adore them. Combining the virtues of his unmatched painterly skill with his inventiveness as a sculptor, they look fantastic in every setting they are displayed. Two exemplary examples happen to complement each other, the King and the Queen vases.

King and Queen Vases -1952 -Picasso

 Henri Matisse (1869-1954), another great artist whose pieces I own, was a French Fauvist (wild colors) and modern artist. He was often compared to Picasso, his close friend and rival. Matisse was extremely influential to Modernists and, because of his beautiful colors and interesting compositions, his work is very desirable. For this reason, I felt my collection should include Henri Matisse.

 Moreover, his art, much like Picasso's, was thought to be crude and over the edge by the art establishment. In fact, he was included in the category of "Fauve" which meant literally "wild beast" because of the exuberant colors that he and the other Fauves became famous for. Matisse's early work was reminiscent of the Impressionists, with his simple broad brush strokes, and similar subject matter -such as portraits, bathers, and dancers. My collection would never be complete without owning a Matisse and I found a perfect piece in "Marie-Jose en Robe."

COLLECTING ART: FOR PLEASURE AND PROFIT

Marie-Jose en Robe -1950 -Matisse

The Jazz series -1947 -Matisse

I was attracted to the dynamic blues and yellows in this picture. While Picasso was known for his design, Matisse was known for his vivid colors. When I bought it, this piece was desirable because of the beautiful colors, design and simple brushstrokes. Since it was a lithograph I was able to pay a lower price. A painting of this quality would be, even a few decades ago, in the millions of dollars.

Another purchase of works by Matisse that I made, more recently, was part of the well-known Jazz series of 1947. I have three pieces from this series of 20 that he made from cut paper collages with vibrant colors, poetic texts, and circus, theater, and mythological themes. Matisse was frail and ill at the time he made them. Since he had limited mobility he couldn't paint or sculpt but was able to cut colored paper. Eventually they were made into prints and became very popular. I had to have some of them in my collection.

My collection also includes an early Joan Miro (1893-1983). Miro was originally courted by the Surrealists but moved into his own style of abstraction which was very influential to other artists. His pieces are very colorful and whimsical with wide open backgrounds -like colorful petri dishes. His influence can be seen in many abstract artists including Calder and Basquiat.

Three Characters from a Greek Tragedy -1931 -Miro

COLLECTING ART: FOR PLEASURE AND PROFIT

Fernand Leger (1881-1955), as previously stated, was one of the first artists in my collection and is one of my favorites. He was a well-regarded French artist, with his own take on the Cubist style. His paintings focused on geometric shapes and cylinders. His figures were often painted in the style of an art school teacher showing his students how to draw people, starting out with cylinders and shapes to illustrate volume. It's no coincidence that he was one of the great teachers of painting in his day, and a major influence on the young Americans who went to Paris during the Jazz Age. His work had an industrial feel too, in part, earned the hard way when he was a soldier in the trenches during World War I in charge of maintaining artillery. In the early days of my collecting, I decided to purchase a major painting by Leger. I was going to splurge and make his painting a centerpiece of my collection. I went to the most prestigious gallery in New York at the time (Perls Gallery) and purchased a large oil for just under $100,000. I knew I was taking a big risk with a large amount of money but I was ready to take the plunge. To my credit, it's considered by many to be a masterpiece and I've had many requests to lend it out to museums and art shows. I have a great museum-quality frame on it, too. It is truly one of my favorite pieces and, although I have even had offers to buy it, I would never think of selling. It is still one of the most important works of art in my collection.

Le chien et un oise au dans la paysage -1952 -Leger

Alberto and Diego Giacometti (1901-1966) were brothers who collaborated making unique sculptures, paintings and furniture. Their sculptural work consisted of tall elongated figures, almost like stick men and women. They painted portraits that looked scrawny as well with the paint applied in daubs and muted earth tones. Moreover, the sculptures look like they were squished with his hands—not polished at all. Five years ago, a Giacometti sculpture broke auction records for the most money ever paid for a sculpture—$68 million dollars. Since I thought very positively about his work, I recently purchased one of his famous "Ostrich" sculptures which has delicate thin outlines of an Ostrich and an air of elegance similar to his other sculptures. I replaced the ostrich egg which is easily removable with a more colorful egg which I believe enhances the beauty of the piece. I hoped the artist wouldn't mind the egg change.

Marc Chagall, while in Paris in the early part of the 20th century, experienced Modernism's "Golden Age." His work reflected many styles, from Cubism, to Fauvism, to elements of Surrealism, and definitely Expressionism. He lived from 1887-1985. Chagall was born in Belarus and was of Jewish heritage. His life and career were built in France and his work was immensely influential. One of my first purchases was a Chagall poster based on one of his major oil paintings. I didn't realize at the time that it had no investment value but it didn't matter to me because it was so beautiful. Chagall was also included in the first five pieces that I bought at a Sotheby's auction in 1980, sight unseen. Over the years, I've also purchased several of his small oils; one is a circus scene with a clown, another is King David with Bathsheba. Chagall painted many variations of the circus and stories from the Bible.

The pieces above have vibrant colors, lively designs and depict a narrative. I also have a lovely large watercolor of a bouquet of flowers and a flying figure which is iconic to Chagall. I was drawn to the surreal beauty in his works as well as the fact that they consistently hold their value.

Guy Pene du Bois (1884-1958) was a Modernist American painter from Brooklyn, in spite of his French-sounding name. He started out in the early 20th century as a cartoonist and newspaper article writer for the New York Post. He depicted upscale well-dressed cafe society

COLLECTING ART: FOR PLEASURE AND PROFIT

Ostrich -1958 -Giacometti

King David with a Harp -1965 - Chagall

Circus Scene -1978 -Chagall **Le Repos -1980 -Chagall**

A Dramatic Moment -1946 -Guy Pene Du Bois

of the 1920s with stylized figures reminiscent of Europeans artists like Toulouse-Lautrec. At an art fair at the Park Avenue Armory, I was able to negotiate for less than half of the asking price which incentivized me to buy the painting. I thought I was getting a terrific bargain. Unfortunately, after further research, I realized it wasn't such a great price, since the dealer jacked up the original price to make it look like I was getting a great deal. But I still love the piece.

And, of course, one of the greats and a favorite of mine, Salvador Dali (1904-1989), the Spanish Surrealist who gained international celebrity not just for his talent but also for his antics. Known as a great self-promoter, as well as an eccentric personality, Dali, with his dramatic mustache, had his hand in nearly everything, from painting to sculpture to animation to design. He was extremely influential to other artists. I own numerous artworks by Dali that are always interesting to look at and keep increasing in value. However, Dali is also discussed in the chapter on fakes and frauds.

I also collect a number of limited edition Dali sculptures that are iconic images based on his paintings. For instance, the *Space Elephant, Lady Godiva with Butterflies, Profile of Time* (the iconic image of the

**Dahlia Unicornus -1968
-Dali**

**Reve de Venus -1939
-Dali**

Rhinoceros Cosmique -1959 -Dali

melting watch), *Space Venus* and *Surrealist Piano* are images borrowed from his artworks. Dali directly created the idea, the image, the model and specified his wishes in the contract with the foundry. They are truly

fantastic sculptures that were authorized by him before his death and created posthumously. They've been well-accepted in Dali circles, sell at auctions for tens of thousands of dollars and keep increasing in price. I purchased them because of their beauty and truly Dali-esque quality. One of the sculptures entitled *Rhinoceros Cosmique* was created in 1959 during his life and therefore brings the highest price. I believe they're an excellent investment, especially if you like Dali images.

Man Ray (born Emmanuel Radnitzky in Philadelphia in 1890, died in 1976) was a notable American artist who worked in the Surrealist and Dadaist styles of art. His artistic career flourished as an expatriate in Paris during the 1920s, alongside other American artists and literary figures (most notably Hemingway). He associated himself with Surrealists, including Salvador Dali and Max Jacot, and the Dadaist Marcel Duchamp. Man Ray's images often combine elegance and sensuality. He was very inventive artistically, and was an early pioneer in raising photography to the status of an art-form (decades before Cindy Sherman). So you can see why the art history student in me would want to add one of his pieces to my collection. He was a great artist. His *The Lovers* (which, incidentally, was inspired by Lee Miller, a photographer that Man Ray was dating at the time and famously a muse to Hemingway) is one of his most iconic pieces and a worthy acquisition.

The Lovers -1933 -Man Ray

Leonora Carrington (1917-2011) was a fascinating female figure of the Surrealist movement. Early in her career, in the mid-30s, she had a love affair with the famous European Surrealist Max Ernst. They collaborated together on artworks and she painted his portrait. When WWII broke out in Germany, Ernst had to flee and left her behind. They

never reconciled and she was devastated. She had a mental breakdown and was institutionalized for years and given many drugs and therapies as well as abused. One of the drugs was Cardiazol, a powerful anxiety-creating drug (the opposite of what you'd want) which was later banned. Carrington documented her experiences in a novel titled *Down Below*. The good thing is that she resurfaced and lived a clear and productive life in Mexico City. I was always interested in her work, which to this day is undervalued considering her uniqueness and importance in art history, and waited many years for the right piece at the right price to come up for sale. Finally it did and I jumped on it. One year later she passed away at 94. She kept painting up until her last breath.

Sinister Work -1973 -Carrington

 Charles Burchfield (1893-1967) was an American Modernist artist of phenomenal technique and certain Surrealist as well as Expressionist tendencies. He painted very creative landscapes. I was attracted to his lively colors and his expressionistic style of painting which has a dreamlike quality. Fortunately, his work is still affordable and I'm thinking of buying a second piece.

 Alexander Calder (1898-1976) is a very popular American artist who was the originator of the "mobile" and "stabile" art sculpture. A mobile (figure on right) is a hanging sculpture that is suspended from the ceiling, made of rods and balancing geometric shapes. The

ART PERIODS AND STYLES

The Frosted Window -1940 -Burchfield

A Calder Stabile **A Calder Mobile**

Mer de sable -1975 -Calder

distinguishing feature, which Calder perfected thanks to his engineering skills, is the balancing act. The stabiles (figure on left) are immobile sculptures that rest on a flat surface and also have involve rods and balancing geometric shapes. He also created sparse, elegant paintings of geometric shapes. They feature a very colorful and interesting design that is reminiscent of his sculptures.

As a student in a college sculpture class, I copied the concept of his mobiles but instead of using abstract metal geometric shapes, I used everyday objects like a comb or toothbrush that I balanced carefully using a hanger and rods.

And lastly for this section: Reuven Rubin (1893-1974) was an Israeli painter who was also Israel's first ambassador to Romania. He frequently painted the landscape of Israel in a spiritual, translucent, modern style. This was very unique for the nation at the time. He brought his Western and Romanian aesthetics to Tel Aviv, becoming one of the founders of the new Eretz-Yisrael style. Recurring themes in his work were the Biblical landscape, folklore and people, including Yemenites, Hasidic Jews and Arabs. Because of the beautiful colors and design of this landscape I couldn't resist buying this painting.

Landscape near Jerusalem -1968 - Rubin

The work of famous artists in museums opened my mind to a world of possibilities. I pursued art history and studio courses at Harpur College and later in life, actually won a scholarship in a sculpture class at the Brooklyn Museum based on the quality of one of my pieces. I still sculpt and have had several shows but put very high prices on my pieces so that they won't be purchased. I really want to keep them in my family. For me, the talent of some of the greatest artists in the world, like Rembrandt, Picasso, Warhol, Hirst and others, is far too impressive to compete against. Luckily, over the past 40 years, I've collected amazing and beautiful works by some of the most famous artists in the world, almost 100 pieces of art by 40 different artists starting with an El Greco from 1581 to the latest painting by an up-and-coming artist, Hunt Slonem—it still has the smell of fresh oil paint. The vast majority of works of art that are discussed in this book come from my personal collection of paintings, drawings, lithographs, sculptures and photographs. Occasionally, in order to make an important point, I discuss a piece from outside my collection, such as Leonardo da Vinci's *Salvator Mundi*, the most expensive painting ever sold ($450.3 million).

Contemporary Art

Contemporary art, generally speaking, is any art in any medium that is produced after WWII until the present. The category embraces many movements, from Abstract Expressionism through Pop, Minimalism, Post-modernism, Conceptual, Neo-Geo and many other specialized groups. Prices in this category have increased rapidly over the past several decades, surprising even the seasoned experts. Post World War II art (1940s to present) includes Warhol, Lichtenstein, Koons, Hirst, Sherman and many others. Some of the artists are deceased while many are still alive. You can still be considered a contemporary artist even when you are deceased. For example: Basquiat, Warhol, Haring and others are among the category's biggest names. This is the hottest category with huge demand and, paradoxically, an abundant supply.

Here is a survey of some notable art groups, with a brief history,

and well-known artist names associated with each group that I collect and recommend. This list is for either the novice or more experienced collector.

Pop Art

Art styles, like philosophy and politics, tend to swing from one end of the pendulum to the other. While the American Abstract Expressionists of the 50s were still popular, many artists from the print and commercial art boom were beginning to find their way into the fine art market. Andy Warhol, Roy Lichtenstein, James Rosenquist, Robert Indiana, Tom Wesselmann, Claes Oldenburg, and Larry Rivers are some of the early and very influential founders. Their work is noted by having subjects from popular culture, hence the name "Pop." For example, Warhol painted Brillo boxes and Campbell's soup cans onto canvases, while Lichtenstein painted larger-than-life scenes from comic book pages, often with thought bubbles or sound effects, which also influenced the name "Pop."

Birthday Cake -1959 -Warhol Campbell Soup Can -1965 -Warhol

Marilyn litho -1967 -Warhol

 Much credit should be given to the Dada art movement of the 1910s and 20s when Duchamp, Man Ray and others presented popular everyday items such as a shovel, a urinal and a metronome as *objets d'art*. It was actually an anti-art movement developed in Europe and later abandoned but it laid down the seeds for the Pop Art movement that some call the Neo-Dadaists.

 Andy Warhol is probably the most famous American artist of the 20th century. He is the leading and most popular figure of the Pop Art movement, although not the originator. Some experts credit several British artists in the late 1950s, others give credit to Jasper Johns who in 1960 sculpted a bronze Savarin Coffee can filled with used paintbrushes and bronze Ballantine beer cans. Warhol created his famous *Campbell's Soup Cans* two years later in 1962. I purchased a very beautiful collage watercolor of a birthday cake from 1959 which demonstrates his early creative style as an illustrator. Nevertheless, he is the artist most people think of when discussing Pop Art.

 Since the art market recession in the early 90s, the prices of Pop artists' artworks have skyrocketed, especially for Warhol and

Lichtenstein originals, but they are well worth it as they and a select few from this influential American art movement will always hold a great value and likely keep increasing in price.

Over the years, I met several artists who are in my collection. Although I never met Warhol, I visited his studio called the "Factory" while he was alive to purchase a painting. While I was there, I was offered an opportunity to have Warhol paint a portrait of me for the price of 25K. At the time, in the 80s, he didn't have the incredible reputation that he has presently. Instead, he was considered very commercial and not very important. To my sincere regret, I turned down the offer to commission the portrait. I blew my chance for "15 minutes of fame."

Larry Rivers (1923-2002) was one of the very first Pop artists from New York. During the early 60s he lived at the famous Chelsea Hotel, where a lot of artists and famous musicians like Janis Joplin, Sid Vicious and Bob Dylan stayed. I think he is underrated, underappreciated and undervalued. Several fantastic pieces came up for a ridiculously low price so I took the bait. His homage to de Chirico I had to have, since he depicted the de Chirico oil painting of horses that I already owned. The title refers to two common styles that were subjects of his paintings; the anthropomorphic figure and the horses. The *Make Believe Ballroom* is a three-dimensional wooden painting/sculpture.

de Chirico's Dilemma -1994 -Rivers **Make Believe Ballroom -1989 -Rivers**

ART PERIODS AND STYLES

James Rosenquist was originally a billboard painter turned artist who depicted fragmented images of the consumer culture in a collage effect. The unrelated images hint at the artist's social and cultural concerns. He uses vibrant colors and quixotic designs as seen in the painting above. I met him at the Guggenheim in 1990 when they gave him a retrospective show. He wore a red sport jacket that matched his red face. I believe he may have had too much to drink.

The Book Disappears -1977 -Rosenquist

Oldenburg did large-scale public sculptures of everyday objects, like letter-stamps and hamburgers, a telephone, clothespin, etc. He is also famous for his large soft sculptures of everyday objects that are considered the first sculptural expression of Pop Art. I purchased a *Soft Screw* that can be seen later in the book, "Buying in the After Market."

Another notable Pop artist is Robert Indiana, who first created the *LOVE* painting in 1966, later widely distributed as a postage stamp in 1973. The *LOVE* painting has been reproduced so many times—just walk into any Home Goods store and you're likely to see some item with the L and 45 degree tilted O on top of the VE letters underneath. It's quite an impressive brand Indiana created, as he had his work licensed for nearly everything, including jewelry. As a follow-up to his *LOVE* icon, he created the *HOPE* painting using the same design in different sizes and colors, one of which I purchased several years ago in the colors of a rainbow, hence its title *HOPE Wall: Rainbow Roll #1*.

Rainbow Hope -2010 -Indiana

Another artist I met was Roy Lichtenstein at his Whitney retrospective in 1994 just before he passed away. He was very soft-spoken and unpretentious. I reminded him that five years prior I had invited him to my son's bar mitzvah but he didn't respond to the invitation. At the time, I had asked Josh what famous Jewish person he would like to invite for his big day and he requested Roy Lichtenstein. FYI the invitation was quite elaborate and I thought he might at least send back a note saying that unfortunately he wouldn't be able to attend, which I would have been happy to display at the celebration. But we never received a response. When I brought this to his attention, Roy, in a very humble voice, said that somehow no one had relayed the invitation to him.

A few years ago, I was convinced by a dealer I trusted to buy a lovely item by Lichtenstein. She approached me with what she believed was a great investment and she was right. It was a large collage watercolor of a woman, very iconic and typical of his style, which was selling for 300K. This was way above my budget of around 100K but the dealer assured me it would increase rapidly in value. I reluctantly bought the piece because it was truly eye-catching by a

Champagne Glasses -1986 -Lichtenstein

Landscape Mobile - 1978 -Lichtenstein

Untitled Head - 1970 -Lichtenstein

contemporary master and very iconic. Ever since I'd met Lichtenstein at an art fair in the Hamptons several years before I decided to take a chance. Once again, it proved to be a great investment and is now worth over $1 million. Shortly after he passed away, I was approached by the prestigious Museum of Contemporary Art to display the painting in a retrospective of Lichtenstein's work. I was fortunate to meet his widow Dorothy, a beautiful and distinguished lady, at the show and offered my condolences. She thanked me for lending the museum the painting. It was heartwarming. Several years later, I was invited to her home in East Hampton to view Lichtenstein's art studio. I felt I was viewing history.

Palette Ceramic Plate -1996 -Lichtenstein

**Blue Nude -1990
-Lichtenstein**

**Blue Lily Pads -1990
-Lichtenstein**

Tom Wesselmann (1931-2004), another great Pop artist, whose style was often sensual but polished and commercial. He painted women with smooth skin tones and evident tan lines. His paintings look like figurative erotic art from advertising. Easy on the eyes. He's had numerous retrospectives, including a show of *Bedroom Paintings* in the fall of 2017 at Gagosian London.

 I purchased a gouache by Wesselmann 30 years ago. He wasn't famous at the time but I liked his imagery. His colorful, semi-nude woman with cigarette smoke exhaling from her mouth was sensuous and alluring. I purchased the painting for a very reasonable price, compared

to other Pop artists, but the signature was very faint and, as a result, I wasn't sure of its authenticity. I was given the opportunity to visit his studio and meet the artist I hoped could verify the piece. His studio near Cooper Union was crowded with many paintings, as well as the wall reliefs he made from laser-cut sheet metal. He had many assistants and appeared to be very busy. Nonetheless, he made time and was very cordial. He said he remembered the piece and that it was definitely his, and signed the back of the painting just to diminish my doubt. When I purchased an oil painting by Wesselmann 20 years later, his prices had gone through the roof. The painting of the nude woman was so beautiful, I couldn't resist adding it to my collection.

Study for Bedroom Painting -1990 -Wesselmann

Nude Painting Print -2006 -Wesselmann

 Jasper Johns (1930-) has made his way through a few art styles, some related to Pop and others to Abstract Expressionism. He has used various media over the years but is most recognized for his highly original and expressionistic paintings of the American flag. Some of his works have become iconic images in the art world. Although I have just one of his pieces, *Two Flags (Whitney Anniversary)*, it's a very interesting take on the American flag (a popular theme of his) and a solid investment.

 Robert Rauschenberg (1925-2008) is considered a forerunner of Pop Art. He was inter-disciplinary and worked with sculpture and painting that looked a lot like collage. He often added 3D elements and props to his canvas paintings in a technique called "combines."

Whitney Two Flags -1980 -Johns **Star Quarters III -1973 -Rauschenberg**

Cumulus -1984 -Rauschenberg **Bellini 5 -1985 -Rauschenberg**

 Rauschenberg was also interesting for taking up the fight for artists' resale royalty rights in the early 70s. This was after he had learned that the taxi baron Robert Scull resold the painting *Thaw* (1958) that Rauschenberg had sold to him for $900 years earlier. Scull ended up selling it for $85,000 at the New York Sotheby's auction in 1973. Rauschenberg's diligence helped bring about the California Resale

Royalty Act in 1975 that entitles artists to royalties upon the resale of their artworks. The resale right has its origins in the French law enacted in 1920. It's only fair to the artist to receive a resale royalty if he sells his artwork for a substantially lower price than the reseller. As an emerging artist, the price of the artwork is usually quite low. Once the artist becomes well-known, the value can increase exponentially but the artist loses out on the resale. This is unfair to the artist. Recently I purchased a painting from an unknown artist that I thought was quite good. I paid only $100. I told the artist that if he becomes famous and the work of art is worth much more than I paid, I will give him the opportunity to buy the piece back for the price that I paid.

Michelangelo Pistoletto (1933-), an Italian post-Pop painter, art theorist and a major figure in the Arte Povera school, is known for painting photorealistic portraits and figurative works of everyday life on polished steel plates. He later developed an art and social movement, Cittadelarte, in an effort to merge art and socio-economics, including fashion, theater and design. I bought this piece at a charity benefit 20 years ago because of its unique beauty and without knowing anything about the artist. The price was several thousand dollars. I had no idea he was so well-known since I didn't see any of his work in museums or at the auctions. His prices for a unique piece are now in the millions.

Arman (born Armand Pierre Fernandez, 1928-2005), a French-born Pop sculptor, assembled commercial objects into blocks and figures. One painting/sculpture is of a wall of women's high-heeled shoes densely glued together within the picture frame. His works were called accumulations. Another accumulation was of hundreds of shaving brushes encased in the shape of a woman's torso. His use of everyday articles is very creative and caught my eye, especially the piece I bought of a broken violin depicted in a Cubist way.

Peter Max (1937-) was a very popular artist in the 70s when I was a hippie in college. His work was kaleidoscopically colorful and dreamlike and can be considered a combination of Pop (with clear connections to Warhol) and Psychedelic Art. It can be said that his art represented the pot-smoking Woodstock generation with its bubbly-lettered posters and paintings from the late 60s and 70s music culture. He was the cover artist for many important rock albums of the era, and his

COLLECTING ART: FOR PLEASURE AND PROFIT

La Cucitrice -1981 -Pistoletto

Broken Violin -1990 -Arman

Mona Lisa by Peter Max

Family Portrait -2004 -Max

work inspired the Beatles' *Yellow Submarine* film. He had a unique style and created iconic images. Although I consider him a great artist, he is way undervalued because he was rejected by the elite art establishment as a result of becoming too commercial and prolific. That said, he is still the most popular artist on the internet and sells more pieces than any other artist. Because of his popularity, I was able to get him a one-man

show at the Nassau County Museum of Art (NCMA), which was a huge success. In a gesture of good will, he painted a portrait of my family and sold me his take on the *Mona Lisa* that is so fabulous I am proud to display it among my Picassos and Warhols. The family portrait was painted 13 years ago and was provided via a $1,800 donation I gave to the East End Hospice in a silent auction. Peter donated his time and probably received part of my donation. I believe that one day he will be given the credit he deserves as one of the important artists of his generation.

Abstract Art

Picasso, Leger, William de Kooning, Frank Stella, Victor Vasarely, Jackson Pollock and many others are in this vast category. Abstract art has been the most influential category of art in the 20th century and has led many novices to believe they can be artists. I'm sure you have gone to a museum with someone or overheard a person looking at an abstract painting and comment "I could do that." Abstract art made becoming an artist more accessible to a wider audience. In its purest form, abstract art plays with non-representational shapes, colors and designs that try to evoke an emotional feeling. Stella, Mondrian and Kandinsky are examples of the purest form. Cubism is considered one of the first forms of abstract art which challenged the conventional realism of representational art. Developed by Picasso and Braque, Cubism looks at a figure or landscape from several different angles at the same time. There are other categories such as Abstract-Expressionism (Ab-Ex) which usually has no recognizable elements but look more like random squiggles or blotches of paint. De Kooning and Pollock are considered geniuses and are in huge demand, especially by museums.

Willem de Kooning (1904-1997) was an Ab-Ex painter of the New York School. His early work is faintly figurative with female subjects reminiscent of Picasso's female portraits, but instead of a Cubist approach, de Kooning's style is more painterly and even less decipherable. He often used skin tone colors and his paintings tended to be very large in scale. One of the most expensive paintings ever sold

was a de Kooning, sold in 2006 for $137,500,000. I own one in which he painted over a page from *The New York Times*.

**Painting On Newsprint
-de Kooning**

Jackson Pollock Drip Painting

After reading Jackson Pollock's biography, I decided never to purchase a work of his. Beyond the fact that his paintings sell for millions of dollars and a little above my budget, I strongly objected to his lifestyle. He was a drunk and while extremely inebriated, he drove his car with two passengers into a tree in the Hamptons and killed himself and one of the passengers. In protest of his lifestyle, even though he is considered one of the greatest artists, I would never hang one of his paintings on my wall. There's a second fact that disturbs me about his art. He is called "Jack the Dripper" because he is famous for dripping cans of paint on the canvas. It's a little-known fact that he developed this technique by accident. One night he arrived home in a drunken state and had to urinate and decided to relieve himself on a blank canvas. It was then that he discovered a new artistic technique, but instead of urinating he would drip paint onto the canvas. An American Post-modernist painter by the name of Mark Tansey created a great painting that is the perfect representation of the boundaries pushed by Pollock, often carelessly, with his art. Tansey's realistic and satiric painting *The Myth of Depth* depicts a handful of Pollock's artistic peers in a small boat in a vast ocean on the left side of the canvas, and about 20 feet to

the right we see Pollock walking on water. When looking at the painting we feel that his feat is amazing but our logic tells us it's only a matter of time until Pollock falls into the deep dark sea and drowns. This can be a metaphor for the fine line that people walk with alcohol. You feel invincible. Until you are no longer.

The Myth of Depth -1984 -Mark Tansey

Sam Francis (1923-1974) was a California painter involved with the Ab-Ex movement on the West Coast. Very expressive with his use of color and design, and akin to Pollock, he spent most of the 1950s living overseas, painting in a number of places such as Paris, the south of France, Tokyo, Mexico City, Bern and New York, where he picked up his artistic education, to propel his Ab-Ex work.

Untitled -1974 -Francis

John Chamberlain (1927-2011) took the Ab-Ex style of painting into three dimensions by using pieces of scrap metal from crushed or dismantled cars into colorful sculptures He took Marcel Duchamp's notion of the ready-made artwork such as a bicycle wheel or a porcelain urinal several steps further. By twisting, bending, welding and painting these discarded pieces of metal, he expressed the elegance of everyday materials. His sculptures are assemblages that are quite unique and colorful. Several pieces were exhibited at a show at MOMA in 1961 alongside such masters as Picasso and Duchamp. He pioneered the concept that items of little or no value can be turned into art.

Sorry Sotee -2008 -Chamberlain

Frank Stella (1936-) was at first a Minimalist abstract artist but has more recently become an almost Baroque master of expressionism. His early paintings focus on geometric shapes and a variety of color. He created complex lithographs that break out of the traditional four corners of the frame and three-dimensional works in steel, which hang on walls like reliefs as well as on paper. He influenced a new school of lithographers.

Victor Vasarely (1906-1997) was similar to Stella but took abstract geometric art further. He is considered the originator of the Op-Art style, known for creating an optical illusion through geometric shapes. His pieces often have colorful (or black and white) repetitive designs that create the feeling of movement on the canvas through the

curvature and warping of the grids. His work fools the eye and is fun to look at.

Polar Coordinates -1980 -Stella

Igmand-1981-Vasarely **Titok-L -1973 -Vasarely**

Neo-Pop Artists

There are many fantastic living artists with an unlimited supply of great art. It's extremely hard to break away from the pack and become "famous." Having the right gallery representing you, the right

COLLECTING ART: FOR PLEASURE AND PROFIT

timing and opportunities, being part of important private collections, getting outstanding reviews from critics, scoring museum shows, and being seen at art fairs can all help the artist stand out. In the following paragraphs are two of the current giants of the art world establishment, Hirst and Koons, from Britain and the U.S., respectively.

The Physical Impossibility of Death In the Mind of Someone Living -1991 -Hirst

For The Love Of God -2007 -Hirst

 Back in 1988, while still a student at Goldsmith's College of Art, Damien Hirst, the most notorious English artist and certainly one of today's richest, organized an art exhibit called "Freeze" in a warehouse with other school luminaries. They were to become the Young British Artists (YBA). The group's work is often controversial and has received harsh criticism at times. Their art is also very inventive, in that it uses non-traditional mediums; photography, film, plastic fabrications, found objects, performance art, and other sometimes strange concepts are displayed for the viewer's interpretation. Hirst is the most notable and entrepreneurial of the group's founders and is known for displaying and selling an actual dead shark in formaldehyde. Later, he made variations of medicine cabinets with pills on the shelves, a series of paintings with colorful dots, and the $100 million skull made entirely out of diamonds. After making the infamous skull, he then turned around and purchased the piece with other buyers. That's chutzpah! His goal was to increase the prices of all his artworks by having one piece sell for an astronomical price. And it worked. I purchased several of his butterfly lithos and recommend them for their beauty and as an investment.

Black Brilliant Utopia -2013 -Hirst

Butterflies -2013 -Hirst **Cathedral -2009 -Hirst**

 Jeff Koons (1955-) is New York's most famous and most commercially successful artist. In 2013, his orange Balloon Dog sold at Christie's in New York City for $58.4 million, setting a record at the time as the highest price paid for a living artist's work at auction. I've collected several of his smaller iconic balloon dog plates. Like Damien Hirst, he has a factory with artists that produce his public art displays and commissions. His work is almost Pop since he reproduces banal commercial objects. Certainly he embodies a contemporary extension

of Pop Art. He's very collectible, if you can find a great limited-edition piece for a decent price. I was lucky with my balloon dog plates, as I bought them long before his work skyrocketed in price. They were going for $500-$1000 each. In fact, one gallery gave me one for free as a gift when I bought another work of art. Now the Koons plates are easily worth over $10,000 each. Koons' career has an interesting history. After he graduated from the Maryland Institute of Art in 1976, he sold memberships at MoMA. He later became a commodities broker on Wall Street, while making art in his spare time. Although some critics consider him a charlatan, most of the art world considers him a superstar.

Balloon Dog -2000 -Koons

I met Koons several times; once at the Whitney where they were having a show of his art and a second time at Christie's where they were selling a very large heart displayed outside the building. He was friendly, down to earth, surrounded by his six children and very conversational. When I asked if it would be okay to take a picture with him, he didn't even hesitate and shook my hand with gusto.

Yves Klein (1928-1962) was a French artist who is hard to classify. He died of a heart attack at a young age, while he was still exploring his potential. His work consisted of paintings, sculptures and

performance art. Both his paintings and his sculptures were covered in a deep bright blue color. When you see his sculptures, they are very reminiscent of Koons' work or Hirst's diamond skull because he transforms well-known images into unique works of blue art.

Upon visiting a friend's gallery, I came upon a beautiful deep blue sculpture of the *Venus de Milo*. I loved the piece—iridescent and tactile, it stood out from across the room. I didn't buy the piece at the time because I thought it was just a copy of the famous sculpture in the Louvre, but I remembered how it stood out from all the other art in the room. Several years later, it came up at auction. I overlooked my initial reluctance and was ready to buy, especially if the price was right. I purchased the piece at the low estimate and liked it so much that I bought a second sculpture by Klein in which he transforms the well-known image of *The Dying Slave* by Michelangelo with the famous Yves Klein blue. These two sculptures, with their iridescence, truly stand out.

Venus Bleue -1962 - Klein

L'Esclave mourant d'après Michel-Ange -1962 -Klein

Graffiti Artists

I just love this category. Jean-Michel Basquiat, Keith Haring, Banksy, Kenny Scharf, Mr. Brainwash and Shephard Fairey are some of the most prominent artists in this group. I cover most of these artists in the "Up and Coming Artists" section, later in the book. These graffiti artists started their careers by painting and drawing on the walls of buildings or any large flat visible public surface. Although they were defacing property strictly speaking and were condemned early on, graffiti art quickly became accepted as an art form and the artists quickly catapulted into fame and fortune. Basquiat's paintings, which were "discovered" by Warhol and the German dealer Bruno Bischofsberger in the 1980s, sell for many millions of dollars. I wish I had made a purchase 20 years ago.

What is worth noting about Graffiti Art is that, often times, it tries to be political, which is ironic, because the artists are mostly uneducated rebels who break the law by tagging buildings. The messages are never that deep and the way that the artworks are presented, often on dilapidated buildings, can take away from the intended meaning. At its best, it can take an old building and make it beautiful. Graffiti Art tends to be very decorative and figurative. At its worst, the art acts as tags for gangs. When done poorly, it makes certain areas in cities even less desirable to visit. I suppose it will always remain controversial, mainly because it aims to be. Very recently, its influence can be seen on young educated artists out of art school. The style is getting groomed and showing up inside clean contemporary galleries, most notably by hipster artists from Williamsburg and other parts of Brooklyn. Despite its controversy, I'm greatly drawn to Graffiti Art.

As a member of the Board of the NCMA (Nassau County Museum of Art), I was instrumental in securing a solo show for Kenny Scharf in 2016. This was the first graffiti art show at a museum that usually displays less controversial exhibits. It was a huge success and I

had the privilege of taking Kenny to dinner where we talked about many subjects, including art and politics, while he dined on lots of oysters and champagne. We also talked about his early days when he was roommates with Keith Haring and closely connected to the Warhol crowd. To show his appreciation to the museum, he spent a week painting a fantastic and unique mural on the empty white walls of the newly renovated Manes Art and Education Center. Big thanks to Kenny Scharf.

Leeches -1982 -Basquiat

Manes Art and Education Center -2017 -Scharf

Collecting Art by Medium

You can also decide to collect by:

Subject matter: portraits, landscapes, still lives, etc.
Media: sculpture, photography, oil on canvas, works on paper, etc.
Style: Pop, Cubism, Impressionism, Abstract Expressionism, etc.
Date: Old Masters, 19th century, 20th century, etc.

Giclees

A giclee is a machine-made reproduction print on fine paper or canvas with color and clarity that can't be distinguished from the original; but it's a copy. A gallery owner can sell the giclee for $500 instead of $10,000 or more which is the price of the original work of art. It may look the same but because it's an unlimited reproduction it will never be valuable, even if it comes with a certificate of authenticity and a signature. Many artists and appraisers view giclees as a gimmick. Still, there's no denying that giclees put fine art within reach, for many novice enthusiasts. Museums sell giclee versions of masterpieces to generate income and they may be pleasing to look at, but they won't pull in any future income for the buyer.

Posters

Entry-level collecting is often in the area of graphics. The lowest prices a buyer can pay are for art posters that can range in price from just $10 to nearly $100,000 for the rarest Belle Époque masterpieces. Framed properly, a poster is frequently very beautiful and packs a powerful visual punch. I return to the first item I ever purchased, the Chagall poster for which I paid one hundred dollars. A poster is frequently printed, without the artist's permission, in very large numbers, sometimes thousands. While typically not signed by the artist, they are sometimes signed in the plate. That's lovely, but it still means the work in such a large edition has minimal value. If you're just interested in decorating your wall, these will be perfect.

Picasso's Dove (signed poster)

Occasionally, there are posters that are personally signed by the artist. I purchased several of these and, because they are signed, they do have some value. I purchased the famous Picasso *Dove* poster, of which 50 were signed by the master in order to raise money for the International Peace Conference held in France in 1962. The actual one-of-a-kind drawing of the *Dove* by Picasso sold at auction several years ago for $500,000. I tried to bid at that auction where the estimate was 100-200K. Obviously the item was way underestimated. So I bought the signed poster for a mere $10,000. I really wanted the *Dove* image because it fit so well with the charity I created years ago, the Manes/American Peace Prize Foundation. Furthermore, I liked the image so

much that I had the Picasso *Dove* tattooed on my right shoulder and my upper molar crown. Yes, on my tooth.

Lithographs

For the beginning collector who is looking for a low price and the potential for the work to increase in value, I would recommend purchasing a lithograph by an artist you admire and an image you love. For the layman, a lithograph is an image that is made of a polymer coating applied to a flexible plastic or onto a metal plate. Then the image is transferred onto paper, with a limited print-run (or edition). The artist creates a lithograph so that he can offer a beautiful item to the public for a lower price than a unique piece. The litho is a work of art that the artist carefully monitors in its creation and then numbers and signs individually. It's always best to buy a litho that has a low quantity, such as 10 to 100 pieces. Usually the larger the edition, especially over 100, the lower the value. For instance, I have several Picasso lithos in my collection including *Nature Morte, Mother, Dancer and Musician,* and *Tête de Femme* and they have all increased substantially in value because they are limited-numbered and signed editions.

Nature Morte -1962 -Picasso

Dancer & Musician -1959 -Picasso (signed poster)

I also have five ceramic vases by Picasso. Despite being part of a very large edition of 250 to 500, they still increase in value every year. It's difficult to buy a one-of-a-kind pieces by Picasso because of the price. Therefore, the multiples are very much sought after. Ceramic vases with original Picasso designs can be purchased at very reasonable prices.

Ceramic Vases by Picasso

Another exception to the rule regarding large editions is the Jeff Koons "balloon dog" plates created 20 years ago in an edition of 2,300. They sold for $500 at that time and were often given out to influential collectors and museum curators as gifts by dealers. In 2015, one of these plates sold for $50,000. Somebody must have been dying to own one. Since then, the price has stabilized at around $15,000.

Koons' Dog Balloon Plates

Photography

 Photography was considered a craft for many years, a form of documentation or journalism, but has more recently attained the status of a traditional art form. From its early days in the mid-1800s to the present, artists have embraced photography to capture a moment in time in its actuality, instead of rendering what the artist chooses to see. Almost any respected museum has a curatorial department and galleries dedicated solely to photographic art and in the last three decades, the collecting and investment potential of photography has radically expanded. My collection includes photos by Robert Mapplethorpe, Cindy Sherman, Nan Goldin, Peter Beard, Ansel Adams, among other notable figures who have been responsible for the elevation of photography from craft to art. Most photographers stick to this medium exclusively, and many collectors restrict their collection to photography.

COLLECTING ART BY MEDIUM

Robert Mapplethorpe (1946-1989) was a great photographer who was very influential in the art world. His work still remains affordable by most standards and I think it will grow in popularity and value. He was very controversial because of his erotic photos of the underground BDSM scene in the late 60s to early 70s in New York City. His other oeuvre during his short life of 42 years is quite intriguing and beautiful. He took very sensual photos of flowers, as well as numerous photos of well-known celebrities, almost all in black and white. One of the photos I own is a portrait of the actress Isabella Rossellini. After the purchase, I happened to meet Isabella at a gala at a restaurant in Bellport, New York, where she has a home, and asked her to sign the photo. During our conversation, she said she remembered posing for the photo and "how sad it was" regarding his dying of HIV/AIDS while still so young. The last exhibit of his work when he was alive was at the Whitney Museum in 1989 and was one of many that stirred controversy and a heated debate about what sort of art should be publicly funded,

Photos by Robert Mapplethorpe

specifically by the National Endowment for the Arts. Mapplethorpe was a central figure in the controversy, since he had extremely erotic and unsettling imagery, such as one self-portrait of him with a bull-whip in his anus. From one extreme to another, his overall work was just as beautiful as it was culturally shocking at times. His life and art certainly brought a lot of awareness about the AIDS epidemic among gays in the art community in the 70s and 80s. I purchased 2 photos of his *Rose* in honor of my mother whose name was Rose.

Nan Goldin (1953-) is a good follow-up to Mapplethorpe, as her photography focused on drug use as well as the LGBT community. In her first show, she photographed drag queens in Boston. Later, when she moved to New York City, she photographed gay culture, punk culture and the heroin addicts in the Bowery district of NYC. For the latter, she was criticized for glamorizing addiction and depravity. Her own struggle with opioids has furnished the latest subject matter for her often disturbing series of photographic soul-searching.

Christmas at the other Side -1972 - Goldin

Jimmy Paulette -1991 - Goldin

Iceberg -2005 -Salgado

Sebastiao Salgado (1944-) is a Brazilian photographer, known for his photojournalism and the social commentary in his work. Later in his life he concentrated on unusual dramatic black and white photos of nature scenes and animals. One recent exhibit in Chelsea was of his photographs of the Kuwait oil fields and fires. In 2014, the documentary about his life titled *The Salt of the Earth* garnered a Special Prize at the Cannes Film Festival. The film reflected how he changed his direction from photographing graphic scenes of depravity and starvation throughout the world as social commentary to beautiful and unique scenes of nature and animals.

Matthew Barney (1967-) considered one of the most important multi-media artists in the world, won the 2000 Europe Prize at Venice Biennale early in his career (1993). He is a graduate of Yale and, among the highlights of his illustrious career, he created several edgy and post-modern films that became art installations. *The Cremaster Cycle* is a series of five films that are very stylistic and cerebral. He also worked with the singer Bjork, who was his partner, on a carefully-staged film. He continues to make art films that are visually and intellectually challenging, such as his 2014 feature film *River of Fundament*. His photographs, often taken from his films or related to them, are very surreal and thought-provoking. I don't claim to understand his work but it certainly fascinates me.

The Menagerie of the Queen -2004 -Barney

Men's Locker room -2005 -Barney

COLLECTING ART: FOR PLEASURE AND PROFIT

 Ansel Adams (1902-1984) was one of America's most important photographers in the early years of the 20th century. Known mostly for his devastatingly beautiful landscape photography of Western America, namely Yosemite National Park and other locales, his photos were all shot in black and white and had great depth and stunning sharpness. I only own one Ansel Adams but it's my favorite landscape photograph. It's so redolent of Americana. Looking at it, I feel that Jimmy Stewart should walk into frame and talk about angel wings (an undiscovered outtake from "It's a Wonderful Life").

Yosemite -1935 -Adams

Lion Cubs -1976 -Beard **The Reader (Fragonard) -2002 -Muniz**

Turning from nature to animals: Peter Beard (1937-) is an American artist, photographer, diarist and writer who lives in New York and Kenya. He takes unique photographs of African animals and people and then enhances the photo by having local people draw on the borders of the photo. Some photos feature his journal writing superimposed on top of the photograph. He integrates newspaper clippings, quotes, found objects, animal blood and sometimes his own blood into the photo. Thirty years ago, he had a large gallery in SoHo where you felt you were walking into an African hut with all the animal photos everywhere. The prices ranged from rock bottom up to several thousand dollars. Now a typical photo with native drawing is worth over $50,000.

Vik Muniz (1961-) is a great example of the importance of being unique in contemporary art. He's a Brazilian who started out as a sculptor, which influenced the tactile nature of his work. He created a series of photos using chocolate syrup placed carefully on iconic images of famous paintings. I purchased *The Reader*, a well-known image from a famous painting by Fragonard. If you find this interesting, look up his photos of Kama Sutra poses made out of dead Floridian love bugs.

I would like to comment on Cindy Sherman. There has always been a creative aspect in photography but some experts give credit to Cindy Sherman for putting photography on the map as a definitive contemporary art form. A conceptual photographer and art film director whose career hasn't been without controversy, she became famous in 1983 for her *Untitled Film Still* photos that depict a glamorous woman in unsettling Hollywood film scenes that challenged the art world's conventions of beauty and grace. They appear to be scenes from classic movies but she poses in each photo with a vacant, vapid look on her face that parodies *The Stepford Wives*. In her next series, History Portraits, she depicts herself in portraits from the Renaissance and Baroque works of art. The illusion confuses the viewer with its authenticity, as she always has something odd in the image, and she continues to take photos based on specific themes. Since the early 90s, many areas of photography have become serious works of art, especially vintage pieces from the early years of photography, possibly because of Cindy Sherman.

Photos are akin to lithos in the limited quantities printed. In the case of Cindy Sherman, the film stills are 20 each in the smaller size and

3 each of the same image in the larger size. A photo bought in 1985 for $5,000 is now worth over $100,000.

Cindy Sherman Self-Portraits

 I was fortunate to meet her at a Man Ray exhibit at the Jewish Museum. The museum was quite empty when I noticed she was walking alone in the next room. I quickly sidled up to her but not too close to scare her. In front of us was a work of art wrapped in burlap that reminded me of something the artist Christo did many years later. She agreed and proceeded to walk around the museum with me. I did most of the talking while she listened and occasionally commented. I felt honored to be in the presence of one of the greatest photographers of our time and was surprised that she continued to follow me around the exhibit. I met her another time by invitation to the opening night preview of a movie she

directed called *The Secretary*. The movie was visually very artsy but never released to the public. I took a picture with her at the dinner that followed and then sent her a note asking her if she would like to have dinner with me. Unfortunately, she was dating Steve Martin at the time and wasn't available. Her photos are a fabulous investment and have skyrocketed in price over the years.

Deceased photographer's images (including Man Ray, Alfred Stieglitz, Andre Kertesz, Diane Arbus, etc.) have become much more valuable over the past several decades.

Some collectors only collect "vintage photos." The term has several meanings. An old photo of a scene from the past can be called "vintage" but collectors use the term "vintage" when they refer to photos that were printed during the artist's lifetime. An Ansel Adams that was printed during his life is vintage and very valuable, as compared to a print of the same photo printed after his death.

In general, collecting photos is a less expensive hobby than collecting paintings. But they can be equally beautiful, creative and interesting—and a solid investment.

Chez Mondrian -1926 -Kertesz self-portraits

Kid Holding a Hand Grenade -1962 -Arbus

Drawings and Watercolors (works on paper)

These are one of a kind, unique works of art. Aside from paintings, they are the most expensive and the best investments. Many collectors limit their collection to drawings. I recently attended an exhibit at the Met of Renaissance drawings from the Lehman collection that was very well received. (New York's Morgan Library is best known for its drawing collection.) Drawings and watercolors tend to increase in value at a greater rate than lithos or multiples but slightly less than paintings and sculptures. A black-and-white drawing is usually less valuable than a colorful watercolor. Presently, if you wish to buy a unique artwork by Picasso or other very high-priced artists, but can't afford an oil painting, it's best to buy a drawing or a watercolor. A very nice Picasso drawing could range in price from $50,000 to $1 million. Keep in mind that several of his lithos also go for $300,000 or more. When the price of an oil painting is above my price range, I resign myself to buying a work on paper. For instance, I wanted to add a Jeff Koons and a Damien Hirst to my collection. Their paintings go for hundreds of thousands or millions of dollars, but a good work on paper could be purchased for 1/10th the price. And, don't forget, it is still a unique work of art and more likely to increase in value than a multiple.

Paintings

Original oil paintings are the most valuable and the best investment for an art collector. Before the creation of lithography, an artist would make more than one copy of an oil painting if it was in demand. The artists hired students and apprentices to help them copy a popular piece. I purchased an El Greco (*St. Francis and Brother Leo Contemplating Death*) and thought it was a one of a kind, but after further research I found out that there were actually 30 paintings by

him of this subject that are almost exactly alike. I borrowed a rare book through an inter-library loan that was entirely about this particular painting and reviewed all the various versions that existed. Of course they couldn't be carbon copies, but the artist did try to make them as similar as possible. Apparently, the t. Francis theme was very popular in Spain during his period in the 16th century and probably was readily sellable. El Greco certainly capitalized on the theme, creating a number of variations. The painting is shown in later chapters.

Another Old Master painting I own and thought was a one-of-a-kind is by Pieter Brueghel the Younger and is called the *Bird Trap*.

A beautiful winter landscape with snow and ice skaters, which I later found out was printed on Christmas cards. I bought out the entire supply of boxes that was available and send them to my friends and family every holiday season. How terrific is it to own a painting that has become an iconic image for Christmas. To my surprise, there were over 100 almost exact copies of the same painting by Brueghel. It must have been a very popular theme and very sellable.

Bird Trap -1565 -Brueghel

Sculptures

Sculptures can be from any period, in clay, bronze, stone, plastic, wood, metal or combinations of these. Rarely do art collectors

only collect sculptures but instead, like me, combine sculptures with paintings and drawings. Most artists paint and sculpt, but there are many artists who only create sculptures. Some renowned sculptors in my collection include Rodin, Nevelson, Archipenko, Oldenburg and Nicki de St. Phalle. Most sculptures are one-of-a-kind unique pieces but many artists created multiples of the same piece. A clay sculpture can be molded and then the form used to cast in bronze. From that mold, multiples can be fabricated. For whatever reason, the art world has decided that if the multiple is less than eight, then the item is considered unique. If the multiple is greater than eight, then it is considered one of a multiple.

An example of a great sculptor to collect is Auguste Rodin (1840-1917), a French sculptor best known for *The Thinker*. Although his approach to how he depicted the figure was very controversial, he gained notoriety and fame during his lifetime. Perhaps it was his working-class background, and some have even wondered if it was his poor eyesight, that made his observations of the human body rough around the edges. He loved depicting natural body types. His unfinished, expressive style lent itself well to the Impressionists' work. As a budding stone sculptor myself, I was inspired by Rodin and carefully studied his works at the Metropolitan Museum of Art. Even though I loved his sculptures, in the early years of collecting I didn't purchase his pieces because I

**The Kiss -1901-1904
-Rodin**

**Eternal Springtime -1884
-Rodin**

didn't understand his market. Some of the sculptures cast during his life were more expensive, and some that were cast after his death were less valuable. Also, there were different sizes or "reductions"—small, medium and large. So I studied his market and became confident enough to purchase two of my favorite pieces of all time, *The Kiss* and *Eternal Springtime*. The vast majority of his sculptures are marble or cast in dark bronze. In 2006, *The Kiss* was being auctioned by Christie's. One of his most famous casts next to *The Thinker*, both were part of his epic *Gates of Hell* commission. It had a shiny gold patina which was extremely rare (only ten were made) and it looked fabulous. Although it was the smaller version (15" high), it could be seen from way across the room. I had to have it. It looked ten times better than the bronze. Thankfully my bid was successful. Several years later, *Eternal Springtime* came up for auction during a very slow art buying season. I had a maximum bid in my mind which was even less than the low estimate. I was amazed when the hammer struck on the gavel and I was the successful bidder, in what (I believe) was a bargain price. I am now the proud owner of two fabulous Rodins.

Maquette for Hello Paris -1983 -Chadwick

Geometric Statuette -1914 -Archipenko

Another important artist is Lynn Chadwick (1914-2003), a British post-war sculptor noted for his abstract steel figures of angular

and jagged shapes. His series of "beasts" at the Venice Biennales in the 80s was monumental. He was knighted in 1964 and made a French Commandeur de l'Ordre des Arts et des Lettres in 1993. With the rise of Pop Art in the 60s, the trend for his work waned, but his public commissions and private sales kept him relevant throughout his career. He had a unique sculptural style that was very attractive. My piece has two shiny brassy facets that contrast against the dark metal body.

Alexander Archipenko (1887-1964) was a Cubist artist and sculptor, and one of the few artists that exhibited at the first showings of Cubist art in Paris between 1910-11. He was noted as the first sculptor, after Picasso, to sculpt in the Cubist style. His later work looked like a cross between Cubism and geometric forms and the work of Henry Moore with smooth, round, curvy type figures. I always liked both his angular sculptures as well his smooth flowing sculptures. The right piece at the right time and the right price came up and I grabbed it.

One artist I had seen peripherally for many years but always thought he was a painter is Fernando Botero (1932-). The most recognizable artist from Latin America, he is known for his depiction of the obese man or woman dancing or looking in the mirror in a very elegant, sensual and beautiful manner. Most of the materials I had seen were paintings and I was surprised to learn how impressive and sensual his sculptures were. A few years back, I attended a show of works by Botero at the Nassau County Museum of Art (NCMA) and was captivated by the sculptures he created, especially one particular piece in the show. It was a bronze piece that combined a figure of a large nude sensuous woman reclining with one knee flexed and a figure of an over-sized bird on top of the woman's abdomen. I didn't own any of his works and decided this would be an excellent Botero to add to my collection. I found out the name of the gallery that loaned the piece to the museum and negotiated a fair price. As usual I did my due diligence by checking Botero's prices at the auction houses, and realized I was offered the piece below wholesale. The woman and bird are now exhibited in my house in a very prominent space in my living room next to my Rodin *The Kiss*.

It was quite reasonable to believe that the artist had a penchant for large women based on the subject matter of his paintings and sculptures.

COLLECTING ART BY MEDIUM

Woman and Bird -2006 -Botero **Woman -2009 -Botero**

**Dawn's Landscape -1975
-Nevelson**

**Maquette for Sculpture
-1976 -Nevelson**

However, I was very surprised when I met him and his wife at the show that both were tall and thin. I wanted to ask him why he paints large women but I didn't want to appear gauche.

 Several months later, one of the auction houses was selling an attractive Botero painting of a woman holding a fan and dressed in a very sensual outfit. I decided this painting would look great next to the

73

sculpture. I'm now the proud owner of two Boteros.

Rather than create a separate category devoted to "female artists," which I think would defeat the message of equality, I'd like to address the topic of equality with an inspiring quote from one of my favorite sculptors, Louise Nevelson. *"I'm not a feminist. I'm an artist who happens to be a woman."* Political art or activist art doesn't even try to make money; it tries to spread ideologies, more than anything. A great example is the Guerilla Girls in the 70s in New York who protested and sponsored art shows and encouraged museums to exhibit female artists. They plastered the streets of N.Y.C. with their ads. Their gimmick of wearing gorilla masks on their heads became very iconic. I think their movement helped a lot to promote women artists and they occasionally reappear today. I saw one of them speak recently at a New York Art Fair symposium. She still hid her face behind a *Planet of the Apes* gorilla mask.

In my collection, I have many paintings and sculptures of women by male artists. A woman is considered by many to be the most beautiful subject in nature. However, aside from photographs by Cindy Sherman and Nan Goldin, I realized I didn't own any paintings or sculptures *by* a woman. My mission was to balance my collection and add several female artists to it. There are many great female artists, including Georgia O'Keeffe, Mary Cassatt, Louise Bourgeois, Lee Krasner, Louise Nevelson, among others.

I became fascinated by the sculptures of Louise Nevelson (1899-1988). She was of Russian-Jewish descent and developed her unique sculpting style in New York while studying at the Art Students League. She combined wooden objects into interesting architectural creations and then painted them in black, gold, or white. They are unique, fascinating and very ingenious. I now have two of her sculptures, one in white and another in black.

Another great female sculptor in my collection is Niki de Saint Phalle (1930-2002), a French-American artist and one of the first female sculptors to work large-scale. Some of her figurative sculptures are very Botero-esque, depicting large-sized women, but more colorful. I own three pieces by her and love her colorful and childlike forms.

**Nana with Handbag
-2000 -Phalle**

**Arbre and Dragon -1993
-Phalle**

**L'Oiseau Amoureux
-2000 -Phalle**

Conceptual Art

Almost anything and everything not considered traditional painting can be considered Conceptual art. Sometimes it can combine painting and sculpture, as in the works of Robert Rauschenberg and Christo. Rauschenberg stemmed from a Pop Art background and made painted collages, combining them with found objects (even taxidermy) onto canvas or in a constructed display. Christo is known for draping or wrapping an actual building or bridge or an object with fabric.

Some believe Conceptual Art started with Marcel Duchamp

(1887-1968) and the Dadaist movement. In 1917, he entered a urinal, which was signed "R. Mutt" and titled *Fountain*, into a groundbreaking exhibition in New York. The work was rejected. It was later displayed in a different gallery and is now regarded by art historians as a major landmark of 20th century Modernism. Duchamp made the art world aware that any object taken out of its normal context can be considered a work of art. In fact, you don't even have to make the art. Signing your name to any object is enough. Duchamp was way ahead of his time. Fifty years later Jasper Johns and Warhol took everyday objects and displayed them as art.

Fountain -1917 -Duchamp

Contemporary art, such as Maurizio Cattelan's 2013 KAPUTT exhibit of five full-sized horses hanging from their heads on a tall wall, has taken conceptual art to absurd heights. There are even wilder creations, like Chen Wenling's massive sculpture based on Bernie Madoff (the Ponzi-schemer that ran off with all of his investors' millions). It's a little vulgar to show here but if you want to search for it, it's titled *What We See May Not Be Real*.

Conceptual Art comes in more forms too, like performance

art, or video installations. Other installations are interactive, like Felix Gonzalez-Torres' *Candy Installation* which consists of a tall pile of candy in the corner of a gallery. Attendees were invited to take a piece of candy, making the pile smaller and smaller as the exhibit progressed. The artist giving away free candy is a great reason to visit a gallery. It's important to remember that every artist has intent behind their work and, where something may seem ridiculous, there's often meaning to be found.

When it comes to Conceptual Art, I prefer works that are more tangible. Rauschenberg is perfect for me, as I relate to the works because they are more painterly and have great colors and texture. Also, I value artists who learn the rules before they break them, the way Picasso was a classical painter before he co-created Cubism with Braque, and the way Christo could draw realistically from life before draping mountainsides with cloth. There is plenty to admire and be amused by with Conceptual Art.

The Wrapped Pont Neuf -1985 -Christo

Incidentally, I would like to add this anecdote about Christo and his wife and art partner Jeanne-Claude. A few years ago (2005), I was sitting at a table with my wife at Orsay, a French restaurant

on Manhattan's Upper East Side. At the very next table was Christo and Jeanne-Claude. You can always recognize Jeanne-Claude by her exuberant red hair. They had just completed the famous saffron-draped Gates, the public art display in Central Park. I leaned over and told him how much I admire his work, and that I owned one of his seminal artworks, the *Pont Neuf* piece. He was very grateful and quite conversational, inviting me to his studio downtown. After they finished their meal and were about to leave, he handed me more than a half bottle of wine, asking me if I would like to finish whatever was left in the bottle. How could I refuse such a generous offer by an accomplished artist? I enthusiastically accepted his offer and became blissed-out on the wine and the entire experience.

Investing in Art

Good news! You don't have to be rich to assemble a fantastic collection as evidenced by the Vogels. Herb (1922-2012), who worked at the post office and never earned more than 23K per year and Dorothy who worked as a librarian, lived in a tiny 450 sq. ft. one bedroom rent-controlled apartment in Manhattan. They pooled their resources and assembled one of the most important art collections of the 20th century with over 4700 pieces of art that they displayed on the walls and stored in their closets and under the bed. The New York Times referred to them as the "In Couple." Although Herb dropped out of high school, he went back to study art history at free seminars given at NYU. They worked during the week and visited galleries and artist studios on weekends. Artists included in their collection include Roy Lichtenstein, Chuck Close, Cindy Sherman and hundreds of others. Their first acquisitions in 1962 were a Picasso ceramic vase to celebrate their engagement and several months later a sculpture by John Chamberlain to celebrate their wedding. The artist Sol Lewitt sold his first painting to them. The artwork had to be affordable, transportable by taxi or subway and fit into their apartment. If they liked a piece they would find a way to make a purchase by borrowing or bartering. Artists knew that their work was going to join an important collection. Christo traded a collage in return for cat sitting. In 1992, the Vogels decided to transfer their entire collection, worth millions of dollars, to the National Gallery of Art. Eventually, most of their collection was donated to the National Gallery

Today the interest in collecting art is huge for its beauty and

prestige but also for its potential as an investment. Now that you're educated about various art periods, it's time to look at the numerous factors that will influence you, as an art collector, in the worldwide art market. As art fairs take over the globe, in New York, Shanghai, Miami and Europe, you might ask yourself is fine art actually a great investment? The quick answer is Yes! Definitely. For fine art enthusiasts and collectors, such as myself, art is the perfect investment. Unlike stocks and bonds that you put away in a drawer or exist in a cloud, you can surround yourself with beautiful art which also increases in value.

Global Art Market Share by Value in 2017

- Spain 1%
- Italy 1%
- Switzerland 2%
- Germany 2%
- France 7%
- Rest of World 6%
- US 42%
- UK 20%
- China 21%

© Arts Economics (2018)

Art sales each year are in the tens of billions of dollars. According to the European Fine Art Foundation's Art Market Report, the total sales in 2016 were $60 billion—up 1.7% from 2015. The market share for that overall sales figure is the U.S. with 29.5% of the market, the U.K. with 24%, and China with 18%. While art auction houses are losing some clientele to art dealers and sales at fairs in the U.S., under-the-hammer sales have been doubling in Asian countries like Japan and India with an overall 40.5% share of the market.

The strong dollar in 2016 had some negative effects on international sales outside of the U.S., but in China, Old Masters were up 13% and Modern Art up 4%, while in Europe and the U.S., Contemporary Art went up by 4%. Europe, it should be noted, is the largest global exporter of art and antiques.

In terms of art as a strictly financial investment, I recommend the Deloitte Art & Finance Report. According to the 2016 report, Post-War Contemporary works of art delivered compound annual returns in the past 40 years of 10.85%. This is above the performance of other U.S. equities, bonds, or real estate. So we definitely have a consistent increase in art as an investable asset. It's true that an art collection doesn't pay dividends that can be re-invested like stocks and bonds. However, art has proven to be a more secure investment than keeping your money in a bank that pay 1-2% interest. Owning art doesn't generate income but it does generate value over time, as pieces become more rare and in demand.

For collectors who like numbers, up-to-date information can be found in The Art Market report published by Art Basel and UBS or the Deloitte Art & Finance Report. Recently, total sales are about $60 billion and have been rising each year. Contemporary works of art delivered compound annual returns in the past 40 years of 10.85%. This is above the performance of other equities, bonds or real estate. Although art isn't as liquid an asset as stocks or bonds, it can be sold at numerous auction houses around the globe and is considered by many financial advisors to be a viable part of a total portfolio.

Art is increasingly considered a legitimate alternative investment class by serious investors—some of whom devote 10% of their assets to fine art. Heritage Auctions conducted a study which analyzed 626 auction records that compared one auction to the next. The results revealed that 58% made an annual average return of 0-10 percent and another 24.5 percent made an average annual return greater than 10 percent. About 17 percent lost value from one sale to the next. When compared to the stock market, where 75% of stocks increase in value and about 25% lose value, the art market actually outperforms the stock market.

For me, art collecting isn't specifically for profit, it is my passion.

I've invested in other areas, but with my art history background and admiration for art, I get the most satisfaction from investing in art above anything else. It's a tangible possession that can add beauty to your environment as opposed to stocks that exist on paper or your computer. As for art's liquidity, you can put your piece for sale at a moment's notice, in one of the many auction houses, Christie's, Sotheby's, Swann, Phillips, Heritage, etc.

While fine art investments are a consistently low risk, lower than investments in stocks and bonds, the art market can fluctuate by a few percentage points. For example, there was a huge boom in the 80s but the art market slipped in the 90s, partly influenced by the waning of the Japanese economy. The Japanese purchased art in the 80s and then flooded the market in the following decade when their economy collapsed. I bought some of my best pieces in the slow 90s marketplace at great prices, including my best Warhols which increased more than tenfold in value. Additionally, the 2000s saw the market come back up with competitive pricing based on high demand. Experts always say you can find the best deals in a slow market. The increase in prices at recent auctions in November 2017 was remarkable. The da Vinci went for a record $450 million, which undoubtedly created a frenzy for all other categories of art. I tried bidding on six different items and was outbid by a significant amount of money each time. The art market is hot as hell.

I must point out that when you buy art you must take into account the numerous transaction costs, including dealer markups, auction house commissions, insurance and storage costs, and tax consequences when you sell. Also, the market doesn't always go up. The market index dropped from 100 in July 1990 to 45 in July 1993 and remained at a lower level until 2001. It took another four years for the market to regain its 1990 prices. Since 2005 the market has been steadily increasing. The Japanese collectors, bidding up the prices in the 1980s when their economy was flourishing, had inadvertently caused a bubble in the art market which later burst in a sell-off when their entire economy went into a longstanding depression. But, as I mentioned, when prices are down can be the best time to buy. Buy low, sell high.

When investing in art, it's important to note that work by Old Masters like Rembrandt don't increase in value as rapidly as Modern

and Contemporary Art. Although a Rembrandt is still a solid investment and the price of the piece will increase, albeit more slowly. Notably, with Modern and Contemporary Art, people's opinion of an artist's work can change quickly, and the value is more volatile, especially if they haven't had a recent show at an important gallery or museum. In the contemporary market, an artist could be hot one year and cold the next, what Wall Street would call a "high flying stock." The Old Masters tend to act like stocks in the Dow (GE, IBM), slow and steady growth.

Plan on owning a painting for several years before you consider re-introducing it onto the market to make a profit. When buying from an auction house, you pay a 25% commission on buying and 10% on selling; therefore, you need to make at least 35% profit on reselling. Based on those upfront costs, you need to hold the piece for a few years. One of the most thrilling parts of art collecting is to get a piece at a great value and watch the artist's demand grow over the years, raising the monetary value of your purchase and your collection.

The art market is subject to the rule of supply and demand. The supply is dwindling while the demand is increasing due to two major factors: the worldwide expansion of museums and the expansion of private collections. Donors seek immortality and cities seek respectability and increased tourism. In the past 25 years, there have been hundreds of new museums around the world and the number of wealthy collectors has multiplied by twentyfold.

Art collecting, as I see it, is a long-term investment. A thoughtful collection will grow and hold value for the collector and their family. All-in-all, the current art market is thriving and will continue. Collecting art is not only a great investment but you can enjoy its beauty. Plus you get an education.

My passion for art has enhanced my life. Each piece has a story and history. The lives of artists fascinate me. With each new acquisition, I often learn something new about different periods in world history and the circumstances under which the piece was made. Sometimes, when I have had long days in my medical practice, I come home, seat myself anywhere in my house, and face a fascinating piece by a great artist. Each piece has its own unique characteristics of color, technique and passion, and becomes part of a larger family of brothers and sisters.

I love to share my thoughts and experiences in art collecting with my family and friends, and readers.

Collecting art can also be lucrative. Many articles and books discuss fine art as one of the safest and most accruable investments. I started out with lower-priced pieces and worked my way up. Now some of the pieces I bought many years ago are worth ten times what I paid. In this book I share my insights regarding where and how to buy, which artists, and what pieces are the best investments. Basically, as a collector, you try to get a fabulous piece at a reasonable price that will retain its value and possibly increase, similar to buying a stock on the exchange. As Warren Buffett says, "Buy into a company because you want to own it, not because you want the stock to go up." I agree with his philosophy. Buying great art and enjoying it for years is the best reason to buy. That said, buying art is a significant investment and it's reasonable to think about whether your purchase will hold its value or even grow in value. Art is increasingly considered a legitimate alternative investment class by serious investors—some of whom devote 10% of their assets to fine art. Heritage Auctions conducted a study which analyzed 626 auction records comparing one auction to the next. The results revealed that 58% made an annual average return of 0-10 percent and another 24.5 percent made an average annual return of greater than 10 percent. About 17 percent lost value from one sale to the next. When compared to the stock market, about 75% of stocks increase in value while about 25% lose value. The art market actually outperforms the stock market.

Things to Consider Before Investing in Art

Think Before That Splurge Purchase

1. *Avoid getting caught up in the hype.* When any asset class performs well, more investors want a piece of the action. It doesn't matter if it's a stock, a piece of real estate, or a work of art.

Recent art appreciation has triggered great excitement, but in reality only a handful of artists and artistic periods will generate those big returns. Investors can fall into potentially hazardous behavioral patterns,

hoping to ride the wave when a certain asset class performs well. Buying that soon-to-be-discovered artist or that under-appreciated art form about to become the next big thing often proves to be the exception, not the rule. When considering an art investment, it's important to step back and take in a holistic view of your investment assets, future cash flows, and other tangible assets.

2. *Think of art as you do venture-capital investing.* Just as every start-up is unique, so too are works of art. Some have a track record of success, but many are prone to the whims of the market.

What drives passionate collectors is the individual interpretation and unique viewpoints on artwork. That subjectivity also explains why it's difficult to think of art as an asset class. Unlike start-ups, art has no balance sheet, cash flow, or earnings to help determine its true value. That said, there are several companies that track the trends regarding specific sectors of the art world as well as specific artists. Artnet and ArtPrice are both internet databases.

To determine the fair market value of a piece of art, consult with a reputable art adviser or do your due diligence to find the sale prices of comparable works. The gallery or auction house may be able to provide documents showing their own related sales. As mentioned, the internet is a terrific source of information regarding past sales for most artists.

It also pays to learn about the artist's life and times. That information can provide context and meaning for an investment piece. Note any prestigious awards or fellowships the artist has won, academic positions held, and notable collectors or museums with the artist's work. That information can offer positive indications about the long-term value of a piece.

3. *Shun the belief that art sales translate to resale value.* The secondary market for art is limited beyond works from "blue chip" artists. Also, before you calculate any windfall, remember the Internal Revenue Service considers art as a collectible -meaning the tax rate on gains is up to 28 percent. Add that to the expenses associated with acquiring, owning, and selling art, and you may NET only 55 to 60 percent of the sale price.

Reflecting the wide spectrum of possible returns from an art investment, focus on non-financial benefits first. View any financial gain

as an additional benefit rather than an expected outcome.

4. *Value a collection as more than the sum of its parts.* This adds a layer of complexity to appraising a collection and raises important planning considerations for wealth transfer or philanthropic giving.

While art often is viewed as an investment, many behavioral factors come into play, as with any other type of asset. Every asset serves a purpose in your portfolio, so identifying that purpose in advance is critical to determining long-term objectives for it.

We all want to benefit from something that's doing well, and the art market is no different. Yet at day's end, it pays to think about the purpose art serves in both your life and your portfolio.

This book isn't about flipping art for profit; it's about landing gems you find beautiful on their own terms and whose worth hasn't been inflated beyond reason by speculators or hype. I have a bias. Collecting art and art history are not just a hobby, they are my passion.

Some say that art collecting is in a bubble like the real estate market of the early 2000s but I can assure you it's definitely not a bubble that will burst. The market may fluctuate but art is the best illiquid asset there is. It's why so many of the wealthiest people on earth invest in art; although not as easy to convert back into cash as say gold, your money is safe. Gold and diamonds base their value on their rarity and luster. The attraction is similar for art, but art is spiritual and historical. Gold and diamonds are worthy and undeniably valuable but are shallow objects compared to the historical and manmade richness of a fine work of art. Art is representative of the artist's time and interpretive of his or her feelings. Art is simply and complexly "Art."

The Most Expensive Paintings Ever Sold

Until November, 2017, the three most expensive paintings ever sold were *Interchange* by Willem de Kooning for $300M, *The Card Players* by Paul Cezanne for $250M, and *When Will You Marry?* by Paul Gauguin for $210M.

All were private sales, not auctions. In fact, 80% of the most

expensive paintings sold were through private sales. The first, a de Kooning, was sold by the David Geffen Foundation and bought by the founder and investor of Citadel, Kenneth C. Griffin. The second, the Cezanne, was sold by the Greek shipping magnate George Embiricos and bought by the State of Qatar. The third most expensive painting, by Gauguin, was sold by the Rudolf Staechelin family (one of the great Swiss 20th century art collectors) and bought, again, by the State of Qatar. Qatar sits on the world's third-largest natural-gas and oil reserves. In June of 2017, Qatar had a diplomatic crisis when it was accused of funding terrorism. Despite the turmoil, one hopes that precious Western artworks will always remain preserved and perhaps re-enter the market at some point, while still retaining those high values.

| **Interchange -$300M** | **Card Plaers- $250M** | **When will You Marry-$210M** |

Recently, at Christie's New York, I watched the bidding on the most expensive painting ever sold at auction. Leonardo da Vinci's *Salvator Mundi*. At Christie's preview reception, which I attended, it was estimated to fetch between $100-$200 million but shattered all previous records by selling for $450 million. I watched the protracted 19-minute bidding war online. The successful bidder was on the phone and chose to remain anonymous. Some believe it was an American, possibly Jeff Bezos (CEO of Amazon and richest man in the U.S.). Since there are no da Vinci paintings in this country (although there are drawings), the desire for the painting to stay in the U.S. was great. Others believe it was a Chinese billionaire who purchased a $170 million dollar Modigliani in 2015. It was later disclosed it was purchased by Abu Dhabi's Department of Culture and Tourism.

The story of the painting is fascinating. It's documented in the collection of King Charles I in the 1600s. In 1900, it was purchased by Sir Frederick Cook, a British art dealer. Poor restoration attempts were made during both those periods. Then it was in storage and was re-discovered in 1958, when it was sold at auction for £45. In 2005, two Upper East Side art dealers named Alex Parish and Robert Simon bought it for $10,000 at an estate sale in New Orleans, of all places. They were able to get da Vinci experts to authenticate it and had New York University painting conservator Dianne Dwyer Modestini work on the restoration for two laborious years. Then it passed through a few more hands before it got to Christie's. The two dealers sold it to a Swiss art dealer named Yves Bouvier in 2011 for $80 million, then Yves Bouvier sold it to Russian billionaire Dmitry Rybolovlev for $127 million and he brought it to Christie's.

Before and after restoration of the Salvator Mundi by da Vinci

There is some debate about the authenticity of the piece. In its 2005 purchase, it was damaged and "greatly overpainted," according to Simon. With such extensive restoration work, some speculate that the

work of other artists accounts for 80% of the painting. This means that only 20% of it was done by da Vinci's hand.

In terms of the auction, this sort of massive purchase is used to anchor a new cultural center by donating it to a city or a museum, namely Abu Dhabi's Louvre. Already, as part of Christie's marketing campaign, the painting has been on tour and had nearly 30,000 people line up for a glimpse of it. Culturally, it's extremely valuable.

The Hampton Press quoted me in an interview that I did right after the big news: "Notwithstanding that it is a fabulous painting, it is incredible to me that a painting that sold for £45 in 1958 and then $10,000 in 2005 has now become the most expensive artwork ever. Whoever did the restoration should be congratulated and share in the huge profit. I hope that 20 years from now they still consider this painting a da Vinci. Otherwise a lot of people will be terribly disappointed."

Sotheby's, as if trying to compete, put up Amedeo Modigliani's 1917 painting, "Nu Couché (Sur Le Côté Gauche)" at a starting bid of $150 million. This was the highest starting bid for a painting at Sotheby's and it sold on May 14th, 2018, for $157.2 million, barely over it's estimate, in what some speculators considered an overall "B+" offering of artworks. It's quite different from the da Vinci painting, with it's controversial subject matter, although it is a nice looking piece.

Nu Couché (Sur Le Côté Gauche) -1917 -Modigliani

Art Trends and Branding

Trends run the market. An artist in favor at one time can be replaced by another artist a year after. Often trends are created by influential people. It took design mogul Charles Saatchi's dropping in on a "warehouse" show in Britain, in a green Rolls Royce, to discover a young Damien Hirst. That was 1990. He is now the one of the world's richest artists. Saatchi went on to discover many others from the Young British Artists group and helped place London as an influential center for valuable art sold. He now has his own self-titled museum.

Back at the start of the 20th century, the center of the art world was in Paris. Picasso, Toulouse-Lautrec, Monet and many of the highest-selling artists of the 20th century were from Paris or passed through. Everybody who was anybody in the art-world wanted to be in Paris: buyers, artists dealers. Keep in mind that Paris was also an engineering marvel and "The City of Light." At that time, art and innovation (or the application of innovations like Edison's light bulb) made Paris the most beautiful city on earth.

Then with the advent of the Chrysler Building in 1928 and the Empire State Building in 1930, New York got noticed— big time! The city attracted everybody, especially artists, and the engineering marvels inspired artists to be innovative and creative. Industrial paints began to be used in the 30s, 40s and 50s by Abstract-Expressionists and Non-Representational artists like Pollock and Mondrian, respectively (the latter being a European that settled in Manhattan). Trends and the fascination with them were moving westward from Europe to the

Eastern U.S. primarily, and certainly the two very harsh World Wars scattered many Europeans and creatives to America.

Art and tastes evolved and, whether or not you like a certain style at its inception, you have to adapt and let the artists lead you. It's a very different market now. The days when patrons went to an artist's atelier or studio and bought directly from them are gone. There were auctions and large commissions, certainly, but the art market was not nearly the dominating force it is now. Now many collectors, including myself, have paid large sums of money for artworks based solely on seeing a digital JPG image or a photo in a catalogue.

Judging art has less to do with content and more to do with instinctual sense. Art has the greatest impact when it makes the thinking part of the brain talk to the feeling part. Auction house specialists say that prices are whatever someone will pay.

I recently read about the Damian Hirst "shark in a tank" in formaldehyde being sold for $12 million. The shark was caught in Australia and prepared and mounted in England under the direction of British artist Damien Hirst. Charles Saatchi, the same famous collector that discovered him, commissioned Hirst to produce the work for $75k. The agent selling the art was Gagosian. The item was presented to the Tate Museum which was constrained because of their budget to only offer $2 million. Steve Cohen a very rich collector showed an interest in the piece and bought it for $12million. He wasn't sure what to do with the piece and decided to donate it to the MoMA over the Tate. Hirst, Saatchi, Gagosian, The Tate, Cohen, and MoMA; all involved in the sale of a decaying dead shark.

I decided that I needed to own a piece by Hirst for three reasons:

1) I like his imagery, especially the butterfly pieces.

2) He's a name I wanted to add to my collection. I try to own a piece by almost every important artist.

3) His prices will most likely continue to rise so he is a good investment.

Since his pricing for a unique piece was several hundred thousand dollars, I decided to search for a litho. I purchased *The Cathedral*, from a lovely series, which featured many butterflies in a circle. The diamond

dust in the piece makes the entire litho sparkle. I also bought another butterfly piece which depicts several larger butterflies and sparkles with diamond dust. When people look at my collection, they love both pieces. They're not as controversial as his dead shark. Incidentally, the piece's real title is *The Physical Impossibility of Death in the Mind of Someone Living*. I also appreciate his clever titles.

Another artist who is considered an expert in branding is Jeff Koons. I offer this quote by Kelly Thomas, an ArtNews writer: "JK made banality blue chip, pornography avant-garde, and tchotchkes into trophy art, with the support of a small circle of top dealers and rich collectors." I totally agree with this statement and, as with Damian Hirst, I purchased several items by Jeff Koons including his "balloon dog on a plate" in 5 different colors, his porcelain puppy dog flower pot, and a series of photos by him of his most iconic images which included Michael Jackson with his pet monkey "Bubbles,". I also purchased a blow-up plastic elephant, and a sculpture of him and his ex-wife Ilona Staller (who was also a porn star known by her stage name "Cicciolina" and a member of the Italian parliament). I show photos of both artists' works, earlier in the book.

In general, most works of art purchased directly from an unknown artist will almost never again resell at their original purchase price. What is judged to be valuable is determined by major dealers, later by auction houses, a little by art critics, and museum curators. Many investors believe the art trade is the least transparent and regulated commercial business in the world.

In the early 1900s, it Picasso was making headlines in Paris and Europe. There's a fascinating story that I read in Norman Mailer's biography about young Picasso, which I think helped propel his notoriety and fame. It has to do with the theft of the *Mona Lisa* from the Louvre. And the story also serves to depict how Leonardo da Vinci's work has become even more famous than it was before this incident.

It was the summer of 1911. Picasso was already becoming well known for his masterpiece *Les Demoiselles d'Avignon*, when the *Mona Lisa* painting was stolen from the Louvre. At the time, there was no security at the Louvre. Parisians or tourists could walk in, walk throughout the museum, and take whatever they wanted. Theft wasn't

ART TRENDS AND BRANDING

**Les Demoiselles d'Avignon by Picasso
and Mona Lisa by da Vinci**

encouraged, of course, but it happened. Several pieces went missing each year. So when the Mona Lisa disappeared from its wall at the Louvre, the museum, with the assistance of the police department, said "C'est assez!" (That's enough!) The museum, police, and even some independent sources, offered substantial rewards to anyone who would return the *Mona Lisa* back to the museum, no questions asked. An art dealer from Florence offered 500,000 lire to anyone who bought it back to Italy, but nobody came forward. The French police conducted an investigation. In the proceedings, it came to light that Picasso owned some African sculptures that might have been stolen from the Louvre so he was brought in for interrogation. According to Mailer, the biographer, Picasso nearly peed his pants and fessed up! He, in fact, had bought a couple of African sculptures from a thief that had stolen them from an art exhibit at the Louvre, several years before. Picasso had kept the artifacts in a cupboard and would peek at them now and again, for inspiration. (One can now imagine Picasso working on *Les Demoiselles d'Avignon*, while influenced by his stolen African artifacts.) But Picasso had nothing to do with the theft of the *Mona Lisa*! He relinquished his African pieces to the police and was released from custody. Picasso's association in the news was a form of branding. It's said any publicity,

positive or negative, is good.

Salvator Dali branded himself with his surreal mustache, whose handlebars sometimes reached his eyebrows. Modeling himself as a creative eccentric visionary, he parlayed that vision to work with other big-name creators like Hitchcock, Disney, and Faberge.

An artist like Damien Hirst created hype around himself by making an artwork entirely out of diamonds. Some considered Hirst's $100 million dollar skull kitschy, while others could not help but admire it.

Salvador Dali and his infamous mustache

Buying at Auctions

A common question asked by many new collectors (and even some seasoned collectors) is whether to buy at auction or from a private gallery or art dealer. The answer is: It depends. When I purchased my first group of paintings, I did so from Sotheby's via a mail-in bid. And I believe I obtained an excellent price. My approach to bidding at an auction can vary from piece to piece but there are some standard principles that I apply. First of all, I like to get a bargain. Buy low and sell high, just like in the stock market. I look at the low estimate and try to stay below or slightly above it. If I make a purchase below the low estimate I feel like I'm getting a great deal. But I'm depending on a correct estimate by the auction houses who frequently make mistakes. Occasionally, if I really want a piece and believe the estimate is too low, I will bid above the estimate. However, just like the auction houses, sometimes I'm wrong. I purchased a Vasarely, which I believed was under-priced, and paid double the estimated price. Afterwards, I realized I had probably paid too much. However, recently his prices have increased and my purchase is now showing a profit. Another time, I was searching for a Calder painting and paid above the estimate. If I had waited, I might have done better at a later auction. **Remember: There will always be another work of art by that artist in the future**. Try not to buy on impulse.

The commission in 1980, at either Sotheby's or Christie's, was 10% to the buyer and 6% to the seller (a total of 16%). At that time, there was moderate interest in art, mostly for its beauty but also for its prestige, not so much as an investment. Since the buyers and sellers were predominantly dealers, the auctions appeared to consist of an

elite club which scared away the average collector. The prices were considered wholesale so that the dealer could make a purchase and then add a commission which usually ranges from 10-50%. At that time, I felt very apprehensive about competing against other dealers, so much so that I searched for a dealer to bid for me at the next live auction. I felt I had a better chance of winning a bid if it was done during a live auction with a professional rather than sending in a mail-in bid. The person I eventually hired came into my life after I placed an ad to sell my Valtat paintings in the Arts and Leisure section of *The New York Times*. Ronnie Myerson, a very savvy art dealer, contacted me not because she was interested in buying the Valtats but because she was looking for a client she could sell to. Nonetheless, I hired Ronnie to bid for me at Sotheby's. I told her the two pieces I liked and how high I would authorize her to bid. She succeeded in purchasing a colorful Camille Pissarro landscape painting and an early (1931) surrealistic gouache by Joan Miro. Pissarro was 20 years the senior and mentor to Renoir and Monet and considered by some to be the "father of Impressionism." The painting I acquired was a typical Impressionist painting of trees and a pond with light brushstrokes and warm colors. I bought it for $60K over 30 years ago. Because it was an important piece by Pissarro, the Jewish Museum in NYC borrowed the painting to include in a major Pissarro show in 2010. As an example of how art has increased in value, I was offered $1 million for the painting. I turned it down because I cannot replace it.

A dealer usually charges a 10% commission when they represent a client. I was lucky that Ronnie only charged me 1%. She charged me a very low commission because she benefited by being seen by her fellow colleagues bidding on valuable art. The art world is very status-conscious. That night her status increased. After that one time I did my own bidding without the help of a dealer.

I eventually resold the Valtat paintings without her help at Sotheby's and made a small profit. I give Myerson lots of credit because she did help my collection grow by selling me a number of paintings, including a museum-quality Raphael Soyer oil painting and one of my favorite Picasso pieces, the colorful crayon drawing of his mistress Jacqueline.

Raphael Soyer was a Russian-born American artist who was considered a social realist. He painted portraits of artists, dancers, and the lonely and dispossessed in the city. He died at age 87 in 1987. But I was fortunate enough to have lunch with him in 1985, two years before he died, and showed him the painting I had purchased. He was a diminutive man who walked with a noticeable limp because one leg was much shorter than the other. He wore a six-inch lift on the shoe of the shorter leg in order to balance his body when he walked. As an orthopedic surgeon I understood the need to equalize leg lengths in order to walk properly but I had never encountered the need for a six-inch lift. I was too shy to ask why one leg was so much shorter than the other. He was a very quiet man but offered to add his signature to the back of the painting. I gladly accepted his offer.

Metropolitan movies -1935 -Soyer

Presently the auctions are attended by dealers as well as collectors. Because the latter are willing to pay higher prices for art, the prices are no longer wholesale but tend to be more retail. Occasionally you can get a so-called bargain if everybody else (except you) blinks at the same time. The current commission charged by the auction house is 25% to the buyer and 10% to the seller for a total of 35%. This means that if you buy a piece and want to flip it for a fast profit you have to sell

for 35% more than you paid. That goal would be very hard to reach in a short time, unless you get an amazing bargain. So expect to hold the item for at least several years to even consider making a profit. Just like stocks, to make a profit you need to buy low and sell high.

As previously mentioned, I purchased two Warhol acrylics in the 1990s at auction. One is *Jackie with SS Agent*, and the other is a *Marilyn Reversal*. I paid a very low price for them, since both the economy and the art market was in a recession. Some blame the economic recession on the high interest rates. The art market recession was due to Japanese collectors who created a bubble in the eighties were unloading their art because their entire economy was plummeting.

Jackie with SS Agent -1964
-Warhol

Marilyn Reversal -1976
-Warhol

Any contemporary art collection would not be complete without at least one Warhol artwork. When Pop Art started in the 60s, Andy Warhol's intent was to mass produce art and sell it like merchandise (Campbell soup cans and Brillo boxes). In his famous art studio "The Factory," Warhol and his assistants produced thousands of paintings. After his untimely death in 1987, demand for his work increased greatly. Now, thirty years later, you would have to pay several million dollars for each painting.

A good reason to buy from an auction house is the large inventory they have access to, as compared to a private gallery. You can peruse a catalogue online or order it by mail and see hundreds of items for each sale. You also have the opportunity to see the estimate of prices without having to continuously ask a dealer "how much." One of the negatives of buying at auction is the lack of privacy: it's a public sale. Everybody will know how much you paid. Mind you, you can remain anonymous but once you show the artwork in your collection, people and the media will put two and two together. For high-profile sales, journalists inquire. In some cases, disclosing what you paid for a piece can be embarrassing. For instance, the owner of Nike bought a *Winged Victory* sculpture by Yves Klein for over $400K. A similar item sold one year later for $150K. According to one prominent dealer, "Everybody is laughing behind his back for getting ripped off." On the other hand, if your piece doesn't sell, it becomes "burnt," which means it will be more difficult to sell publicly or privately since the entire world knows the item didn't sell. That's a big negative for the seller. An aggressive buyer can take advantage of that fact by making an offer in the "aftermarket" which is a little-known place where bargains can be had.

Winged Victory by Yves Klein

Buying in the AfterMarket

**St. Francis and Brother Leo in
Meditation -1581 -El Greco**

 What's bad for the seller may be good for the buyer in the "aftermarket" (a private sale right after the auction closes). Somewhere below the low estimate is the seller's "reserve" price, the value at which the seller is willing to part with the item. If the bidding doesn't reach that reserve price, the lot will "buy in" or go unsold, often to be sold privately by arrangement with under-bidders or returned to the consignor. Since the item didn't sell, the seller may want to just get rid of the item behind closed doors and accept a lower price than his reserve price. There are several charges the seller will have to pay even if the piece doesn't sell. The listing of the item and publishing of a photo in the catalogue costs around 1-2% of the value of the piece. So not only does the piece not sell, but the owner loses money. Frequently the seller will lower his

price 5-10% below reserve, if he sells the item in the aftermarket. It was in this way that I was able to buy an El Greco for a very low price.

Theotokopoulos, aka El Greco (the Greek), was a Cretan-born Spanish Renaissance painter of the 16th and 17th centuries who has been credited with being very influential to a later generation of Spanish artists, like Delacroix, Manet, and Picasso, for his use of color and an expressionist style of painting. I've always believed he was the first abstract artist because he painted elegant elongated figures that were far from accurate in proportion. As a result, his compositions were very dramatic and somewhat surreal. One of his paintings was exhibited at the Metropolitan Museum several years previous and I secretly wished I could own it *St. Francis and Brother Leo in Contemplation.* To my surprise it came up for sale at the Christie's Old Masters sale in London and was selling for a very low price. I was wondering why the estimate was so low. Since my daughter Melissa lived in London, I asked her to check out the painting in person. Apparently, the frame and painting, which was 420 years old, was in bad shape and needed to be restored. Secondly, the piece was being poorly displayed on the floor and in the corner of the viewing room. Both reasons would turn off a potential buyer who saw it in person. But thirdly, and most important, the piece was "attributed" to El Greco and not considered a straight out El Greco. Whenever the expert isn't sure of a piece's authenticity, he will declare that the piece is "attributed" to the artist, as opposed to "by" the artist. I asked Christie's who made that declaration. They refused to tell me his name but said he made his decision based on a transparency without looking at the actual painting. To me that was a very shoddy way of authenticating a major work by a major artist. I decided to take a chance and buy the painting and then try to get an authority to view it in person. The worst that could happen was that the piece remained priced at the lower level; there was still an outside possibility that the piece was indeed a genuine El Greco. Another factor that influenced me to buy was that it came from a prominent and old established foundation. Why would they own a secondary level El Greco? I offered 20% less than the low estimate and was lucky enough to have my offer accepted in the aftermarket.

After I secured ownership and the piece was shipped to me, I

had my work cut out in establishing its authenticity. I had to twist a few arms at Christie's to get any information but finally I was given the name of their expert located in a small town in Germany. As I was about to send the painting to him, I discovered a second El Greco expert who was a professor of art in San Francisco. He had written several books on El Greco and was considered equally qualified to determine the authenticity. I contacted the college where he worked and was told he was on a sabbatical and wouldn't return for a year. Just my luck. I waited patiently to contact him, and since he was coming to New York for a meeting, he agreed to come to my house to view the painting. After giving it a close inspection, with help from a bright light and a magnifying glass, he concluded that the painting was indeed done by the hand of the master and was one of the lost masterpieces by El Greco. My gamble paid off handsomely. Recently, another copy was displayed in New York across the hall from the Leonardo's *Salvator Mundi* and sold in London for almost $10 million.

Soft Screw -1976 -Oldenburg

Another recent purchase I found in the aftermarket was Claes Oldenburg's *Soft Screw*, a vertical four-foot solid rubber sculpture of a screw that's flexible and bends at the top. It didn't sell during the actual auction, where the estimate was 30-40K. Previously, it sold in 2014 for 46K. I offered 22K and, much to my surprise, I snatched the piece. A

great addition to my collection, at an extraordinarily low price. Even the auction house experts at Phillips were surprised the seller accepted my offer.

To sum up, the auction houses offer the possibility to find a bargain, a large variety, and an easily accessible price range. The main liability is that the sale is open knowledge to the entire world which may have negative repercussions for the buyer and seller. When the auction hammer falls, the price becomes equated with the value and is written into the archives. The history of art would be quite different if there were no reported auction results. Auction prices help establish a ceiling and a floor for a piece of art.

During the auction process there may be "buyer's regret," which works in two ways: 1) the buyer may regret that he didn't bid high enough and therefore lost out on a great piece of art, or 2) the buyer lets his emotions go wild and bids too high for an item he could have obtained from a dealer or another auction for a lot less.

Bidding on the Phone

A technique I learned and recommend to get the best price on a work of art is to bid on the phone instead of bidding in the room where the auction is taking place. Too frequently, the auction room is filled with egotistical buyers. If they have been outbid, they will look across the room to see who is outbidding them and think to themselves that they are better-looking—or more important or richer or smarter than the other bidder—and let their emotions take control to make a higher bid. It becomes a competition they don't want to lose. However, the people in the room have no idea who is on the phone and are intimidated, because the phone bidder could be anybody in the world (Bill Gates, Leonardo DiCaprio) and may have unlimited funds. Also, since they can't see the person, they can't judge the competition. The bidder in the room is more likely to fold his hand against a phone bidder and the phone bidder will win the piece at a lower price. I started buying at auction by attending the sale in person, but quickly realized that the phone bidder has the upper hand.

An important lesson to learn is to leave your emotions out of the bidding process. Even if you love a work of art and want very badly to add it to your collection, don't be tempted to overbid. Try to establish in your mind the highest amount you want to bid on an item, before the auction, and don't go above that price. **THERE WILL ALWAYS BE ANOTHER WORK OF ART OF SIMILAR CHARACTER THAT YOU CAN BID ON**. Like the example I gave earlier of the Yves Klein Nike sale which went for $400K and sold one year later for $150K. That was a very costly mistake for the Nike CEO.

Buying at the End of the Auction Week

Another technique to get a reduced price is to buy right at the end of the auction season. Usually the auctions takes place twice a year for a period of two weeks in May and November. At the start of the auction week, the bidders are gung ho with lots of cash ready to spend and bid up the prices. By the end of the two weeks, they have already spent the money they intended to use and are much less excited about buying more. Therefore, the bid amounts aren't as high as in the first week. This is especially noticeable late on a Friday afternoon, after the buyer has spent lots of money and is more interested in going home than in buying a work of art.

Bidding in Another Country

Christie's has auctions in 10 locations across the globe and Sotheby's has auctions in nine. Both auction houses are represented in Asia and the Pacific, Europe, Middle East, North Africa, North America, the United Kingdom and Ireland. Worldwide auctions are held in places like London, Paris, Tokyo, New York, Palm Beach, Dubai, etc. Based on this knowledge, I try to obtain artworks I'm interested in by looking at auction houses outside the U.S. where the buyers in that country favor other artists. So my technique for obtaining a lower price is determined

by the country that is having the auction.

The following is good example: 20 years ago, the prices at the auctions in New York were always higher than in all other countries. Probably because there were more collectors willing to spend. At Christie's in London, a Dali watercolor/collage came up for sale.

Promenade -1953 -Dali

It was such an interesting and beautiful work of art with strong Dali icons. I researched the piece and found out it was made for the drug company Wallace Laboratories to advertise Miltown, one of the best selling drugs in the world in the 1950s. Miltown was the first drug used to treat anxiety, stress and nervousness, and was the recommended drug of choice by doctors and psychiatrists before the advent of Valium. In the painting, Dali shows three depictions of a woman and how she changes when she takes Miltown. The first female figure is punched with holes and her skin looks like it's on fire. The second figure is metamorphosing like a caterpillar changing into a butterfly (Dali used the image of a caterpillar and butterfly in many of his paintings). Finally, the third figure is wearing a yellow dress and has a face that resembles a bouquet of flowers indicating how happy and sunny and beautiful she feels (like a flower). I identified with this painting, since my mother Rose, like

many others adults in the 1950s, frequently took Miltown. I was ready to buy the Dali, even though it was somewhat above my price range. Since it was being sold in London, the price was 10-20% less than if it sold in New York, where Dali demand was very high. I eventually paid $200K. It's one of my most cherished works of art in my collection and has been borrowed many times by museums and galleries. It's now valued at over $1 million.

Also, buyers favor artists that are indigenous to that country. I bought a Dubuffet, a French artist, in New York, not in Paris where his prices are 10-20% higher. Twenty years ago, I bid on a Toulouse-Lautrec ceramic painting of which there are 10 similar pieces. In New York, the piece sold for $95K, which was above my bid. However, another piece from the same series was being auctioned in London. Because of the time difference, I had to be awakened from a sound sleep and start bidding on the phone at 5AM (10AM in London) but I was able to successfully buy the piece for $65K. I saved $30K by buying the piece in London instead of New York. A de Kooning in Tokyo, where he is in very high demand, sold for $300K. I bought a similar painting of his in New York for $100K.

**Ceramic -1893 -
Toulouse-Lautrec**

**Logologie -1973 -
Dubuffet**

Celebrity Auctions

A word of caution. Occasionally Christie's or Sotheby's has an auction in which a well-known person or organization is unloading a large collection of terrific and some non-terrific art. For instance, Christie's recently had an auction of the Rockefeller collection. There were hundreds of items including a Picasso that sold for over $100 million. The money either goes to charity or goes to pay off "estate taxes" which can cost upwards of 50% of the estate. The family may have difficulty paying off the tax and therefore sells the collection to raise money. In the case of the Rockefeller collection, the money was earmarked to go to 12 different charities. In the past, there were auctions of the Barbra Streisand collection, when she decided to unload her art deco and art nouveau works of art (she was redecorating). I attended the Marilyn Monroe auction, a Prince Edward auction, an Andy Warhol estate auction, Elizabeth Taylor and others. In general there is so much hype surrounding the auctions that the prices are what Crazy Eddie called "insane." At the Rockefeller auction, I tried to bid on a Miro litho that was estimated at $9K and eventually sold for $52K. I also bid on a Toulouse-Lautrec, *Jane Avril*, estimated at $20K and sold for $56K. People will pay way over the estimate in order to obtain the Rockefeller provenance. Unfortunately, the value of the piece drops precipitously over the years and the provenance becomes less desirable without the hype.

At the Barbra Streisand auction of 20 years ago, there was so much interest that even a ticket to attend the sale was an extremely hot item. People were bragging that they had a ticket. I couldn't get one but I successfully bid on a litho by Franz von Stuck which was depicted in the catalogue in perfect condition. The item was the only piece in the entire auction to go for the estimated price. I couldn't understand why, until I went to pick it up and saw it in person. To say the frame was hideous is an understatement and the matting was badly waterstained.

Worse than that, the paper appeared to have been folded in half right in the middle and the fold was very apparent.

Although I'm uncomfortable making waves and didn't want to get a bad reputation, I refused to accept the piece "as is." If Christies wanted me to pay for the item, they would have to restore the paper fold and supply a new frame and matting. I thought for sure they would reject my demand. To my surprise, the clerk returned to the desk after discussing the issue with her superiors and they agreed to comply with all my requests. Several weeks later, I picked up the restored piece and it looked fabulous. I was elated. The value had just gone up and I owned a beautiful work of art that was originally hanging in the living room of Barbra Streisand.

In conclusion, if you desire to own a piece of art that came from the collection of a world famous person, you will have to pay way over the actual value, and if you try to sell several years later, you may be very disappointed.

Franz von Stuck litho owned by Barbra Streisand

Cruise Ship Art Auction

With name-brand artist prints, drawings and paintings that come hyped with certificates of authenticity, the cruise auction can seem like a win-win for the novice collector. Written appraisals suggest the pieces are offered at reduced prices and that you stumbled into a great investment.

Not so fast. Authenticity doesn't equal value, and doesn't guarantee the rarity of the item or its importance in the art world. Appraisals can be extremely inflated. You need to do your research. Google the artist and the specific artwork to get some history and comparative prices. The auctioneer is trained to draw you in, in order to make a sale. Considering all the cruise ships selling hundreds of artworks, it's very unlikely that you are buying an important and valuable work of art.

Buying at Galleries, Fairs, and Charity Events

 For many years, auction prices were lower than the price of art at galleries. Recently that has changed. The auction prices have become retail and the price of art in galleries can be much more reasonable. Works or art often sell at auction for amounts well above the dealer's price. For example in May, 1998, two enthusiastic bidders at Sotheby's NY took the Warhol *Orange Marilyn* to $17.3 million. There was another *Orange Marilyn* being sold by a New York dealer at one third the auction price. At the auction house, you must decide your highest price within a few minutes and impulsive emotions may take over. "Buyers regret" doesn't apply to buying at a gallery where there's no rush to buy within a timeframe.

 You can also get a discounted price from dealers who might need to meet a payroll deadline or have to pay the taxman or has held on to a piece longer than they wanted. If any of these scenarios exist, the buyer can get a reduced price. Also, there is more negotiating that takes place with a dealer, which is something that doesn't exist at the auction house. The dealer states a price, the buyer counters with a lower price, and then hopefully they meet in the middle. In addition, there may be tax benefits from buying privately, whether it's estate tax upon death or state retail tax. There could be more flexibility regarding the invoice you receive from a dealer as compared to the auction house. Another very positive reason for buying from the dealer is that you get personal attention.

You can discuss what you're looking for, what artist, type of image, price range, etc. The dealer will work with you much more closely than the auction house. For new collectors, I would strongly consider the personal attention you get from the dealer. Once you become somewhat savvy regarding your needs, you can consider buying directly from the auctions.

Recently, I was looking for a Basquiat litho in my price range that didn't have a scary image. A dealer was able to find the perfect piece for my collection at a lower price than I would have paid at auction. The piece sold at auction for $65K at the same time I made the purchase from a dealer for $54K.

Rinso -2001 -Basquiat

I purchased a Kenny Scharf sculpture (*Cosmigenic*, pictured later in the book) for less than half the retail price because the dealer was told by his accountant he needed money to pay taxes.

In summary, although the dealer price may be higher than auction (but not always), you get better service, more information, are less hurried, and your purchase is anonymous to the greater public.

Buying at an Art Fair

Most of the time, the prices at an art fair are very high. But it depends on the venue. During the Art Basel/fairs in Miami and East Hampton or the Park Avenue Armory, the prices are twice what they should be. However, an art fair at a less prestigious venue will have prices that are somewhat lower. You must negotiate or bargain with the seller. They will invariably reduce their price. For instance, I bought Picasso's *Dancers and Musician* litho at the Javits Art Fair (a medium-priced venue) which was being offered at $30K. I counter-offered $15K. The seller said "just cover my expenses for the fair." I asked how much does that mean? She said $18K. I was happy to pay her price, and after checking on the internet for previous pricing, I saw I got a great deal.

At the end of a fair, most dealers want to unload their merchandise so they don't have to pay for the shipping back to the gallery, which could be thousands of miles away on a different continent. If they didn't make the amount of sales they expected, they will lower their prices to encourage a buyer. At the Armory, I saw a Thomas Chambers oil painting from 1860 that was so colorful and surreal (way before Surrealism in the 20th century) which had a price tag of $50K. Although I had never even heard of this artist, the painting was so luminescent, I just had to

Castles of the Mind -1863 - Chambers

have it in my collection. I asked the dealer for his lowest price and he lowered it to $30K. I offered 25. He refused. I came back at the end of the show and reoffered my $25K, and he happily accepted. Afterwards I researched Chambers and found that he was a relatively well-known American artist of the mid-1800s and that two of his paintings are on display at the Met.

I am flabbergasted that great American Art of the 19th and early 20th century is so underappreciated. This painting is so beautiful, interesting, surreal, and over 150 years old, but sells for a pittance compared to a contemporary painting that is a wildly abstract bunch of drips representing nothing. Sometimes I wonder if everybody has gone crazy or if somebody put LSD into the water supply.

Art fairs have been put together so that dealers can compete with the auction houses. An individual dealer doesn't have the inventory that an auction house has for sale at any one time. Therefore, when a group of dealers get together at one show, they can overwhelm the public with a tremendous selection of great pieces. The dealers bring their best pieces and sometimes borrow pieces that they list as sold to impress a future client.

Don't buy at an art fair without first doing your due diligence. You can find comparative prices on the Sotheby's and Christie's websites. Or you can go to the Artnet website and sign up for a day for $25 and they will show you the various prices the artist sold for at every auction around the world. It's well worth the money. For $25 you can save thousands.

Another special feature about art fairs is that they are terrific places to network and meet dealers and other collectors.

Art fairs are important not just to young artists and collectors but to some of the top artists and dealers in the world. The fairs are circus-like endeavors, with scores of galleries rolling into town and setting up displays of millions of dollars' worth of art for a multi-day spectacle. A fair offers the opportunity to see as much work as possible in a short amount of time. Although people shouldn't be afraid to wait and follow up after the fair if they see something they like, on the other hand, if you see something good and like it, you should jump on it before it's gone.

The galleries at art fairs vary depending on the venue. Galleries that specialize in selling works by unknown emerging artists are usually in the price range of $1000-$10,000. These types of galleries sell local artists that they are trying to expose and promote. They're very approachable but, for a collector like me, they don't have any established artists that I would be interested in. In the next tier are two types of galleries that are in the $10,000-$100,000 dollar range. One kind sells *less valuable* artworks by artists who are well-known to the public (frequently lithos). They don't have to worry about educating patrons about the artists. For example, I've seen small Warhols carried by these galleries but often their prices are marked up at the fairs. The other type of gallery sells *better* works by less well-known up-and-coming artists in that same $10,000-$100,000 range. Some of these artists have private collector followings and often are represented exclusively by these galleries. The latter types of galleries tend to be in metropolitan cities and in the "art gallery" districts, like SoHo or Chelsea (NYC). The highest-end galleries show and sell works from established contemporary artists or famous deceased artists. Galleries like Gagosian, Pace or David Zwirner in NYC, or Saatchi, White Cube, or Waddington in London. They are the best examples of showcasing high-end caliber artists often in museum-like settings. These galleries are so big that they draw crowds to their exhibits like museums do. For example, in the fall of 2017, Yayoi Kusama's "Festival of Life" exhibit at David Zwirner's Chelsea gallery was drawing lineups of people around the block, often waiting in cold or rainy weather. Some galleries/dealers, like Charles Saatchi, have expanded into becoming an actual museum (the Saatchi Gallery in Chelsea, London). Some of the galleries and dealers listed above show works on a consignment basis for other collectors. If you can negotiate, you can get a reasonable deal on a work you like.

When you enter an art fair or gallery and don't know what to buy, ask yourself "Which piece would I like to steal?" Once you have circled the room and spent time looking at your object of lust, try to understand why you chose it. The great thing about art fairs is that you, as the collector, are in the driver's seat. You're in the market to buy art and they're in the market to sell. You also don't have the time pressure

that you would in a live auction. Fairs run from Thursday through Sunday sometimes, so you have up to four days to see everything and talk to gallerists. If some dealers seem unapproachable at first, it's often because they may not know you (if you are a new collector). Generally, once you break the ice with them, they love to share information about their artists. So just be confident and go in, look, learn, ask questions, network, and do your research. You will then be on your way to adding a new piece to your collection.

Buying at a Charity Event

Many charity events raise money by selling art in the silent auction and the verbal auction. Artwork is donated by the artist and by collectors, and the artist gains exposure while the collector gets a tax write-off to charity. You, the buyer, also get a tax write-off while doing a good deed as you build your art collection. Most of the people attending these benefits or galas aren't dealers and don't know the value of the artwork; they're often not willing to bid beyond a certain price, despite the noble cause. Sometimes, on a bidding sheet, the charity will list the estimated value of the piece, just to encourage bidding, but the suggested starting amount is often way below the estimated value. The reason is that artists typically donate the works to help the charity raise as much money as possible. If the artists do retain any of the commission price, it's as little as 15-30% of the sale price. Generally, the pieces are fully donated, so the charity isn't as financially invested to start the bidding at a higher marked-up price, as opposed to the auction houses. In the silent auction, the bidding is done on sheets of paper and kept open for several hours. The more valuable pieces are in the live auction with an auctioneer who shows the pieces and takes bids from the audience. It's a fun night out and a place for the artists and collectors to show off their charitable nature. At the same time, the buyer can get a beautiful work of art for a very reasonable price.

I was at a benefit for "Animal Rescue" in which a Lichtenstein painted plate was offered. This was a unique work of art by a famous

artist yet no one would bid beyond $5K. The patrons didn't know the real value of the plate. The piece was significant enough that many years later the Lichtenstein foundation called me about adding the plate to the artist's catalogue raisonne; by then it was valued at more than 10 times what I paid. At another charity benefit, I purchased an important work of art by Wesselmann and a photograph by Mapplethorpe, both for less than half the going price. Since the purchase is also tax-deductible it's a win-win situation: I donate to charity and I receive a valuable work of art for a low price.

Buying During a Recession

There was a minor recession in the art market in the early 1990s. In the 80s, the world economy was strong, especially for Japan. Their stock market and real estate market was going "gung ho." The standard of living was high and the economy was so hot that they started to buy big American companies like Ford Motors and expensive real estate like Rockefeller Center. They were also spending oodles of money on high-priced art, like the *Irises* by Van Gogh for $80 million which set a record for auctions at the time.

Due to their new-found wealth and interest in buying art, the prices for art were increasing every day. As they say, all good things come to an end, as the economy in Japan started to go down even faster than it went up. They entered an economic recession in the early 90s that continued for several decades. Their stock market and real estate markets still haven't fully recovered. The Nikkei (the stock market index in Japan) was 40,000 in 1990 and is 22,000 today. Their economic downturn created a recession in the art market. Not only were the Japanese not buying, they were selling and flooding the market with the art they bought in the late 80s. The art market lost about one third of its value. It was a great time to buy art so I went on a buying frenzy. I purchased the aforementioned Jackie and Marilyn Warhol acrylics for $30K and $40K, respectively. Each piece is worth several million dollars today. In fact, a slightly less colorful *Marilyn Reversal* was up for auction at Phillips in November 2017 and was estimated between $1.5-2 million. The image is so iconic and popular that Phillips displayed it

on their promotional flyers and in a four-page article in their catalogue, alongside famous photos of Marilyn Monroe.

Since then I have continued to buy several items every year as prices continue to rise. It's quite rare for the art market to take a hit like in the early 90s. It took at least a decade to come back to the prices of the late 80s. If we ever get another opportunity like this again, it would be a great time to buy. It is akin to buying stock during the 2008 recession when the Dow Jones average went down to 6,500. It's inevitable that the economy gets back to normal and that stock prices will follow suit. The Dow Jones today is hovering around 25,000.

Most economists think that when there's an economic recession, the art market (considered a nonessential item) also gets hit. Surprisingly, when the entire economy is in a recession, the prices at auction may not decrease; sometimes the prices actually go up. One of the reasons is because people are taking money out of the stock market and real estate, both of which get hit hard during a recession, and rotating their money into tangible investments like gold and art. The art market frequently maintains its value, and when the economy improves the value of the art also goes up. So it's a win-win situation. Art values go up when the economy is doing well since people have extra money to spend; when the economy isn't doing well, art is a great investment as a hedge against deflating stocks and real estate downturns. Evidence for this phenomenon can be seen during the recession of the early 80s and the 2008 recession when prices for art maintained and actually increased for contemporary art. I continued to buy during this time, with the foresight that when the recession was over the art market would go up even more rapidly, and indeed it did. Presently, the economy is steadily moving forward and the art market is also quite strong. I continue to add to my collection with blue chip names, including Jeff Koons, Damien Hirst, and Rembrandt.

In order to round out my collection, I buy artists I always wanted to collect but try to wait for the right opportunity. Sometimes it's never the right time. So if you really like an artist, then jump in and buy. More often than not, the price will continue to increase. Many times I felt that prices for Dali and Picasso were quite high and waited for a pull back,

but I learned you can never go wrong by purchasing either of these artists at a reasonable price.

Death of an Artist

 If an artist dies prematurely, like Haring, Basquiat, Pollock, they can become iconic, just like movie stars. It all depends on whether the artist was popular at the time of their premature death, thereby creating a vortex of want and demand for their work. The art market is caught off guard by the death and collectors panic to try and acquire works by artists who died before their time. With a young artist, collectors may not feel pressure to decide whether their art is worthy of investing. But if the artist dies while they're still young, then the number of their works on the market are locked in; they can't produce more pieces, and what is left becomes highly desirable due to scarcity. Still, the artist's work has to stand the test of time. Van Gogh, Warhol, Haring, Basquiat and

Irises -1889 -Van Gogh

Pollock all have stood the test of time and their art is highly regarded and considered very influential. Mapplethorpe's work, on the other hand, struggled a little after his death, due to some of the shocking imagery that was shown in his last few shows. However, his importance and influence on contemporary black-and-white photography was eventually realized and now he, too, is more highly valued. Still, Mapplethorpe is affordable, compared to Haring, Basquiat and Pollock.

Growing Suite -1988 -Haring

It's a layman's cliché that when an artist dies his prices automatically go up, but it's not always true. For instance, when Andy Warhol, Basquiat and Haring died (1987-1990), the entire art market was in a recession. Consequently, the initial demand wasn't that great for their artworks so their prices went down. In 1990 the prices for Pop and Graffiti art were half the price of 1985. In addition, they weren't considered as important at that time, compared to a decade later when their impact on 20th century western art became apparent. In the case of Warhol and Basquiat, they became the most widely acclaimed artists of the last half of the 20th century.

Regarding Basquiat, you could have purchased an oil for $20K in 1985 that is now worth $10 million or more. Basquiat died prematurely

from a heroin overdose at the young age of 27, and was catapulted to the top of the New York art world in the late 70s and early 80s through his street art and the mentorship of art establishment powerhouses like Andy Warhol. Although I obviously don't condone his drug lifestyle, much like Pollock's alcoholism, I couldn't resist jumping on the Basquiat bandwagon for other subjective reasons. Basquiat's works were colorful and dealt with sociopolitical themes infused with the spirit of street art and poetry. On May 18th 2017, in New York, a 1982 "Untitled" painting of his broke a new auction house record of $110,500,000 at Sotheby's. It's obvious that Basquiat's work is in great demand and prices for his work will continue to rise.

There are exceptions, of course. Some artists are their best salesmen and once they die, the prices go down. Pascal Cucaro is one such example. He peaked in the 50s and 60s selling his works for as much as $50,000-$60,000, but now those same pieces can't be unloaded for more than a few hundred or a thousand dollars. He was a flamboyant character and a great salesman in his time but his estate couldn't duplicate his great personality, so his prices fell.

Sometimes the estates are to blame. When an artist dies, if the estate is wise and wants to preserve their legacy and their prices, it's important that they not flood the market with too many pieces at once. It overwhelms and turns off buyers and is sure to drop the artist's prices. The law of supply and demand goes into effect. The artist's estate has to preserve and carefully distribute his or her works after their death to help facilitate the increase in the prices.

Let's look at Picasso. His prices were high in the 50s and 60s. However, in the decade that he died (1973), his prices skyrocketed and are still going up. Anytime I can find a Picasso I like and that is in my price range, I will buy it. This goes for Dali as well; his prices increased rapidly after he died in 1989 and continue to rise.

Traditionally, most artists have a slow trajectory where they produce more and more at their peak and then taper off in old age. Some, like Picasso or Dali, remain constantly in demand and keep producing at a decent pace, sometimes with assistants. Their prices also increase gradually, at the same pace as their demand and productivity, due to

their incredible reputation and viable brand. Prices, after their death, increased immediately based on the demand by people trying to grab up what was available in the marketplace.

Up and Coming Artists (Who to buy)

Obviously, every artist is unknown until they become famous. Some collectors are like speculators in the stock market. They're willing to take a chance on an unknown artist and hope that one day that artist will become famous and their purchases will increase in value a hundredfold. Like buying Apple stock 30 years ago or Google 20 years ago. As I've stated before, **it's most important to buy art that you like to look at and can live with for many years**. Occasionally, the unknown artist does become famous but it's almost like finding a needle in a haystack. You can find lovely paintings and sculptures at almost every art fair. There are thousands of very talented artists. Only one in a hundred ever becomes famous. You may ask, what does it take to become famous? Like any other field, it takes lots of talent, excellent connections, determination and persistence, lots of luck, and (as previously discussed) powerful branding.

If you like an artist you never heard of, I suggest you buy their work from a prominent gallery that's known for representing that artist. Usually, a gallery will only represent and take on an artist that has lots of potential for a sale since the gallery has limited space and is in business to make a profit.

I usually buy established artists because they have a proven track record of sales and value in the marketplace. But if I like the piece and it's in my price range, I will buy an artist I've never heard of. For instance, when I first came into contact with a Cindy Sherman photo,

I was mesmerized and knew there was something unique and creative in her photography that no other artist was able to capture. In 1985, she was represented by an important gallery in New York and the price was quite reasonable at $5K. That piece is now worth over $100K. As her prices increased, I kept on buying. In the world of stocks, this technique is called "buying up." My investment in her photos was one of the most profitable investments I have made in art.

Other examples in my collection of little-known artists who later became famous are the graffiti artists Banksy, Shepard Fairey, Mr. Brainwash and Kenny Scharf.

Atmosfear -1973 -Scharf **Cosmigenic -1996 -Scharf**

Banksy is an anonymous British artist who continues to hide his identity (what a great marketing ploy). His art is very much in demand. His street art is typically black and white, with splashes of color, and is often activist in nature. Some consider his work pedestrian and politically controversial (like his pro-Palestine stance, with his 2015 graffiti work on the remains of a house destroyed by Israeli air strikes, while on his trip to the Gaza Strip). Some of his failed artistic endeavors are not as tangible to the mass market (such as "Dismaland," a large-scale UK group art show). But of course, art doesn't have to be beautiful to be valued and desired. Frequently, art can be extremely unattractive

and still considered extremely valuable. "Beauty is in the eye of the beholder." It's a cliché but it applies to collecting art. Art, I might add, is also meant to make one think and question life and society, and that is something graffiti artists and Banksy strive to do. Ten years ago, you could buy a Banksy piece from an art show (a painting on canvas, in the style of his outdoor wall pieces) for $5K. A similar piece of his can now sell for $250K.

If you would like a recommendation for two undervalued artists, I would recommend Kenny Scharf and Shepard Fairey. Kenny Scharf was roommates with Haring and Basquiat and still sells for very reasonable prices. While an oil by Haring or Basquiat would sell for six or seven figures, a good oil by Scharf sells for $10-15K. He has a very identifiable style which is quite whimsical. I believe he has potential to increase in value very rapidly.

Shepard Fairey also has a distinctive style and potential for rapid growth. Fairey is known for his *Andre the Giant Has a Posse* and the 2008 Obama *Hope* street art campaigns. I also recommend Mr. Brainwash. He was the star and director of the movie *Exit Through the Gift Shop*, a 2010 Oscar-nominated documentary about the graffiti art scene. (Incidentally, Banksy is interviewed in the film and is listed as the director of that film, although his identity is concealed throughout.) You can still buy an oil painting by Mr. Brainwash for a reasonable price, which could rapidly increase in value over the next decade.

Bomb Hugger -2003 -Banksy

Lotus Target Black -2012 -Fairey

Einstein -2017 -Mr. Brainwash

UP AND COMING ARTISTS

 Mark Kostabi (1960-) is a controversial artist known for his colorful canvasses of faceless figures with stylistic roots in de Chirico and Leger. He came up in the booming art scene of the 80s, and associated with Warhol and Basquiat. He was condemned by the art world when he made it his regular practice to hire other artists for minimum wage to paint his paintings. In 2011, a documentary about him called "Con Artist" was inspired by one of his quotes: "Modern art is a con, and I'm the world's greatest con artist." It's hard to tell if he was being ironic or just seeking attention for the sake of it but his prices plummeted. I loved his *Pegasus* painting which is so colorful and dreamlike and was *selling for a song*. I made the purchase in spite of his negative reputation. I hope the art world changes its mind and gives him credit for his unique style and that his prices properly reflect his talent.

Blue Pegasus -1991
-Kostabi

Untitled Butterflies -2016
-Slonem

 Hunt Slonem (1951-) is an American painter known for his expressionistic paintings of tropical birds in almost transparent cages, inspired by the collection of birds in huge cages housed in his Brooklyn studio. He's also widely known for his multiple paintings of rabbits with long phallic-looking ears and paintings of colorful butterflies. He carefully frames each piece with ornate frames that truly enhance the subject matter. Upon visiting his studio, I was in awe of his large aviary with numerous exotic birds. He generously gave me two large books

which catalogued his many paintings. He's an eccentric figure, and a proud owner of a big Victorian-decorated former plantation house in the southern U.S.

There are so many more, but these are just a few artists who have stood out. The art world is a pyramid. There are very few at the top that are rich and famous, with their work sought-after. The majority are trying to climb up from the base of the pyramid. As a collector, it's interesting to observe. Some artists break through overnight. So buying at the right time is key.

Out of Fashion Artists
(The art of the deal)

 Sometimes an artist goes out of fashion and his prices decline rapidly (i.e. Kostabi). This is similar to a stock that has several bad quarters and sees its prices drop. It may be a buying opportunity. In every decade, there's a new hot artist whose prices rise rapidly; inversely, the hot artist from the previous decade falls in value. Recently this happened to Eric Fischl and Julian Schnabel. Fischl had a couple of well-regarded pieces in the early 80s, *Bad Boy* and *Birthday Boy*, both depicting young boys looking at naked older women in a voyeuristic way. Schnabel painted a Red Hot Chili Peppers album cover that gave him notoriety. Then he went on to direct a Basquiat biopic, as well as *The Diving Bell and the Butterfly* (2007). The latter garnered him a Best Director award at the Cannes Film Festival—no small feat. Both artists were steaming hot in the 80s and 90s, only to fall precipitously ten years later. Granted, one can't fault Schnabel for being an artist and then transitioning to film-making. However, for an art collector, that affects the value of purchased pieces. Be careful when you buy a hot artist. They can fizzle out as fast as they rise up. Recently Fischl's and Schnabel's prices have stabilized and are probably a good buy at this time.

 I always liked the art of Thomas Hart Benton. His elongated, wavy figures remind me of El Greco. A little-known fact is that he mentored Jackson Pollock and was considered a very important artist in the 30s and 40s. He fell out of favor for 50 years. Since I like his technique and use of color, I purchased several oils by him in 2010 for a

reasonable price. Several years ago, the murals he painted on the walls of The New School in downtown NYC were going to be destroyed. Instead, a benefactor bought the murals and had them restored and donated them to the Metropolitan Museum of Art. They're absolutely fantastic. The museum has displayed them for the past three years and, as a result, Benton's prices have shot up.

Study for Palisades -1924
-Benton

Menemsha Pond -1960
-Benton

 This isn't always the case. Reginald Marsh and Raphael Soyer were both highly recognized and sought-after for their "Ashcan" paintings of the depression era of the 30s. They're genre paintings that are dark and represent the down-and-out times of the era. Even though they are excellent artists and well-recognized for their talents, the prices of their works haven't increased over the years and have actually gone down.

 I especially like the Marsh paintings I own, in spite of the decrease in value. I have two scenes from Coney Island. One is of a barker who is encouraging patrons to buy tickets to a burlesque show. I love the way he paints fashionable women of the 30s. The other painting is of the infamous ride in Steeplechase of the rotating wheel. As a child I remembered this ride which went round and round as the centrifugal force pushed your body toward the outer perimeter. The ride also made me sick to my stomach. He depicts a number of curvaceous women being thrashed around. The third piece depicts a crowded doctor's office

Showtime -1940 -Marsh **Steeplechase -1942 -Marsh**

**Doctor's Office -1940
-Marsh**

where men, women and children are packed in like sardines waiting to see the doctor while a lone nurse takes information from the patients. As a doctor, I felt an instant connection to this painting. I love all three paintings and don't care if the value never goes up. Collecting art isn't just an investment based on money, more importantly it's the subconscious emotional connection the collector feels about the piece.

Many artists who were famous and sold well a hundred years ago no one has heard of now, such as French classicist painter and sculptor Ernest Meissonier. He painted realistic Napoleonic scenes and set record sales at the turn of the century. They were gorgeous paintings and very well executed. The trouble is, as I have learned through my love of art history, he lacked the one component that makes an artist place his mark on the art world: **innovation**.

Every artist is unique in some way and each is an original. But it's the innovators who prevail and whom art lovers and collectors identify with. For example: Picasso/Braque and Cubism, Warhol and Pop Art, Lichtenstein with his glorification of 1950's comic strips on a grand scale, Cindy Sherman with her exploration of the non-celebrity

through photography as an art form, and even Jacques-Louis David who preceded Meissonier but is more fondly remembered for his instrumental influence on Neoclassical painting at the height of Napoleon's reign in France. And let us not skip over Auguste Rodin, who sculpted against classical traditions, or Damien Hirst, who broke conventions of what is considered art by displaying dead animals in formaldehyde, or Van Gogh, who invented a thick and colorful painting style; they were all *rule-breakers*. Rembrandt broke with tradition by painting portraits that depicted the real person, not an idealized image of them. These artists disrupted the art world with clever variations on old themes, new techniques, and created new trends. There are many great artists to name but just a handful from the past one hundred years has left their mark indelibly. These great art producers and innovators revolve at the top of the sales charts and continue to fetch higher and higher prices.

My Boston -1996 -Zhang Huan

Several years ago, Chinese artists began to create unique, interesting works of art that the world's art community began to recognize for their importance. Zhang Huan is an avant-garde performance artist from China.He would photograph himself and others in a most unusual bizarre manner, as no other artist had done before. One of his photos depicts him standing among several columns of books with his head smashed through one of the large open books. The photo definitely

makes a statement, and since I didn't own any Chinese artists, I decided to make the purchase through a dealer who specialized in Chinese Art. I also thought it would be a good investment since the market for Chinese art was growing rapidly, as was its economy. Unfortunately the price I paid several years ago hasn't increased and Chinese Art has actually become stagnant in value. With artists like Huan, sometimes art is dependent on shock value and is very relevant and impressive at the moment. Time will tell what the art market has in store for him and my purchase.

Frauds, Fakes, and Heists

I had purchased several pieces from the auctions and galleries of artists I studied in college, including Pissarro, Dali, Miro, and many others. I assumed all the items were legit, since they came from so-called legitimate sources. Well, don't believe it. Sotheby's and Christie's have a disclaimer somewhere hidden in the back of the catalogue that states "we are only responsible for five years." Can you believe that? Five years! If you find out that your purchased artwork is a fraud or was stolen and it is five and a half years later, you can't get your money back. This is one of the big reasons you must do your homework and due diligence whenever you buy art.

Early on, I wanted to buy a museum-quality work of art as a centerpiece to my collection. Up until then, my pieces were between $10-50K. I found an oil painting by one of my favorite artists at the time (my favorites keep changing), Fernand Leger. It was being sold by the top gallery in NYC, Klaus Perls. He had a fabulous collection of major pieces by major artists. He was also the head of the ADAA (Art Dealers Association of America), which gave him extreme legitimacy. After the purchase of the Leger, which I still own, I purchased a beautiful iconic Dali gouache/watercolor that had his famous melting watch and a figure of a woman for $25K. The painting came with a photo certificate verifying its authenticity. How could I go wrong? A purchase from Klaus Perls and a photo certificate. I was so proud to own a Dali—one of my highly preferred artists.

Fifteen years later, I decided to sell the piece and buy a larger

and more important painting and use the money from the Dali to help pay for the next painting. My piece would be worth about $150K by that point. I brought it to Christie's to sell at auction, since I thought I would get a better price using an auction house. But their experts said they couldn't sell it without a letter from the Dali expert authenticator, Robert Deschamps, located in Paris, France. The fact that I had a photo certificate from the top dealer in the country wasn't enough. (I have to give credit to Christie's for doing their due diligence.)

Dreaming of Venus -1939 -Fake Dali

There are so many Dali fakes. A rumor that has circulated is that Dali would sign the bottom of a canvas or litho paper that had no image and afterwards his assistants would create the drawing or painting. Dali is also credited with the famous quote, "The painting is real if I get paid when it sells."

Apparently, Robert Deschamps had been designated as the official Dali authenticator by the artist himself. He was a close friend of Dali, and although he has no official art background, he published the most complete edition of Dali paintings. However, some Dali experts feel he lacks the necessary qualifications to be considered the top authority.

Christie's insisted that I send the image to Deschamps, who required a payment of one thousand dollars in order to authenticate it.

To my dismay, he said the piece was a fake. I couldn't believe it. What did I do now? I had a Dali that was a fake. I called several lawyers and received a lesson in law. When you purchase an item like a painting, it's considered a contract transaction. The statute of limitation (SOL) is five years. Which means the buyer has five years in which to make a claim against the seller. I asked, "Shouldn't the SOL start to run when I discovered that the item was fake?" Most lawyers said emphatically "No." Since it was 15 years prior that I had made the purchase, according to the SOL, I couldn't file a claim for breach of contract. Incidentally, the SOL for a claim of intentional fraud is 15 years. In order to prove fraud, you must establish that the seller knew the item was a fake but presented it as real. So I might have a claim for fraud. The seller Klaus Perls could simply say that he didn't know it was a fake and I would then have to prove that he was lying. This is a very high bar of proof since Mr. Perls had an impeccable reputation as an art dealer. Maybe I should go after the art broker that obtained the item from Mr. Perls and sold it to me. Isn't the broker responsible to make sure that the item is real before they sell it? The lawyers didn't know if I would have a case against the broker. And again it was 15 years later, way beyond the SOL for breach of contract against the agent.

All these questions came up and I couldn't get a consensus as to what I should do. Why not go to law school and try to make sense of this chaotic landscape? I applied to law school but at the same time I contacted Mr. Perls who had retired and closed his business. I was able to track him down and made a call. He was very nice and cooperative and believed that the Dali was legitimate but was willing to refund my $25K, if I would return the piece to him. That may sound fair on the surface but if the piece was real it would have been worth about $125K. Also, $25K put in the bank for 15 years would be worth over $50K. These are all legitimate questions. However, I decided to take his offer, returned the Dali, and entered into law school.

Interestingly, in my last year of law school, I was required to write an original treatise on an aspect of law. My paper was entitled "Art Fraud and Art Theft -A Confusing Landscape." I entered into a competition for the best law student treatise. Much to my surprise, I won the first place and the thesis was published in its entirety (35 pages

and 130 footnotes) in the NYS Law Journal.

Art does get outright stolen sometimes and makes great subjects for films like *The Thomas Crown Affair*. In the film, a rare Monet worth $100 million is stolen from the Metropolitan Museum of Art, just for the challenge it presented to an already wealthy connoisseur. Probably the most famous theft was of the *Mona Lisa* from the Louvre in 1911 by Vincenzo Perrugia, a worker at the museum. The poor guy just wanted to bring the masterpiece back to where he felt it belonged—Italy. Eventually he spent a short time in jail, had his "15 minutes of fame" (to use a phrase that Andy Warhol coined), and continued to live a modest life.

More recently, the artist called Banksy did the opposite: he snuck his own graffiti-inspired paintings onto museum walls, creating quite a viral sensation. You can see the videos on YouTube. Essentially, he would bring in his own paintings into famous museums in London and New York and hang his paintings next to the other paintings. The juxtaposition was quite amusing, having a graffiti painting (with a nice frame, to blend in), next to a Victorian painting. Generally, now, the security is high, especially with video cameras. I strongly recommend against trying to steal from museums or putting your own painting on the wall of any museum.

Banksy painting hung in museum by the artist.

Art Fakes

Thomas Hoving, curator of the Metropolitan Museum, is credited with saying that "up to 40% of the high end art market is made up of forged art." It's a rampant problem. One of the ways to reduce the possibility of buying a fake is to check the provenance. The papers that go with the piece will usually disclose where the piece originally came from and who owned it over the years. That is why there isn't more art stolen from people's homes or museums; it's very difficult to sell a work of art to a dealer or a knowledgeable collector without having the proper papers. However, even with a stellar provenance, a collector can be fooled and I will give you a perfect example. A well-known New York dealer named Ely Sakhai purchased Gauguin's *Vase de Fleurs* from an auction and had it copied. He sold the copy to a Japanese collector together with the letter of authenticity and a provenance that cited previous auction transactions. Unfortunately, the buyer of the copy consigned the work to Christie's at the same time that Sakhai consigned the original work to Sotheby's. Sakhai pleaded guilty to fraud and had to repay $12.5 million to the purchasers of fake Chagalls, Klees, Laurencins and others.

There have been some very famous art forgers over the years. In the last century, to name a couple, there were Elmyr de Hory and John Drewe. Elmyr de Hory died in 1976 of a suicide while under investigation by the FBI and Interpol for art fraud. He was a flamboyant figure that was an art-swindler from very early in his youth in Hungary. He was also an exceptional artist with a knack for copying the style of any artist. He could create works of art that were in the style of say Picasso or Chagall but looked like new works that hadn't been on the market before. He sold many pieces, even to museums, and was quite a celebrity and society figure in his time.

John Drewe was a master forger who also invented provenance, falsified certificates of authenticity, and fabricated invoices. He functioned in the 1980s and (while posing as a nuclear physicist at the time) found a skilled artist by the name of John Myatt. Drewe commissioned Myatt,

initially to just do paintings for his private collection, testing his skill all the while. Then he asked Myatt to copy famous paintings. Myatt was just a working artist, and by the time Drewe's ex-girlfriend gave him up (after she discovered Drewe aging paintings with vacuum dust, varnish, and old frames in the back yard), Myatt became very cooperative with the police and got a reduced sentence. Myatt is well-regarded as an artist now, while Drewe remains the biggest art forgery seller in recent history, with some of his art forgeries still in museums and private collections across the world.

Oleanders -1988 -John Myatt

Oleanders -1888 -Van Gogh

To add to the list, Eric Hebborn is another talented forger—a British artist who moved to Italy and had a gallery from which he sold

his forgeries. He was against the art establishment, as evidenced by his memoir *Drawn to Trouble*. He was found mysteriously murdered in the street, in 1996—the murderer still undiscovered.

And lastly, Ken Perenyi came to prominence in 2013 with a memoir *Caveat Emptor*, outing himself as an expert forger of 18th and 19th century British and American paintings. Incidentally, the title of his book is an expression that means that the buyer is the sole person responsible for finding out that the goods he/she purchases are authentic. He still sells forgeries from his gallery but advises patrons that the pieces are expert copies.

The "art forger of the century" may be the German art forger Wolfgang Beltracchi who, with the help of his wife Nancy, forged hundreds of paintings of early 20th century famous artists including Leger, Ernst, Dufy and others and netted millions of dollars. He bought old paintings by unknown artists from flea markets for several dollars, painted over them in the style of a famous artists and sold them to unknowing clients. One of his clients was the famous art collector and actor, Steve Martin, who purchased a painting in 2004 for several million dollars and then sold it at Christie's for a nice profit in 2006. Beltracchi was able to dupe other auctions houses such as Sotheby's and Lempertz into selling his fake art including what was considered a masterpiece by Max Ernst for $7 million. He believed he actually improved upon the style of Ernst. In 2011 he was finally arrested and sent to "open jail" for three years, where he was able to leave the jail in the morning to work and come back at night to sleep. A documentary movie, which won the German Best Documentary Film award, was made in 2014 about his notorious escapades. This fascinating film depicts the creative techniques he used to fool even the most prestigious art experts.

The lesson from the above stories and personalities is that these types of criminals are alive and well in any age. A lot of them are artists who become involved in criminal activities. For some artists, the notoriety just adds to their fame, such as the forgery by Michelangelo himself in 1496. Yes, even Michelangelo was a forger. He apparently forged a sculpture of Cupid and buried it to age it. He then sold it to a Cardinal. For artists such as him, the forgery was considered a "triumph over antiquity." But for collectors such as me, we must tread cautiously,

do our due diligence with every piece we want to purchase, and use our heads before jumping in with our hearts for a piece that we love.

Non-Authorized Works

Sometimes it's not the frauds you have to look out for but simply the non-authorized works. Many famous artists authorize only a limited number of sculptures or prints to be created at the foundry or with a printer. The artist only signs off on a limited number. However, a foundry or printer can make more than the artist authorized. For example, Giacometti may have authorized 100 sculptures to be made from his mold, but the foundry makes as many as 150. So 50 of the non-authorized sculptures will find their way into the market. If a work is authorized, with papers to prove it, it is worth three to five times more. Some people may still buy the non-authorized work because the price is much lower and it's still a work by an artist that they like. An unscrupulous person may forge the paperwork and try to pass the piece off as if it were authorized. Obviously, if this is done, the market becomes very confusing. Unfortunately, there are many works of art in this category. Having said that, I advise to always go for the authorized work, for authenticity's sake and greater overall value.

Money Laundering Through Art

One of the ways to illegally launder money is by purchasing art. Money launderers love art because the item can be stored covertly in a storage unit, and the money can be stored in an offshore tax haven. Some shady organizations and criminals use their misappropriated funds to invest in valuable pieces of art, for this very reason. Once their payment is accepted, their money is safe in their art purchase and they can eventually sell the work at a profit or break even. As scrutinizing as art auction houses (or individual sellers) can be, when someone offers you millions of dollars for an artwork, it's easy to take it and hand over

the painting happily. That is exactly what happened recently with the 1Malaysia Department Berhad fund.

This particular fraud made headlines, as it involved the famous actor and art collector Leonardo DiCaprio. According to a 2017 Newsweek article, approximately $4.5 billion in assets were allegedly stolen by financiers and their associates that were affiliated with the 1MDB sovereign wealth fund established by Malaysia's Prime Minister Najib Razak in 2009. The Los Angeles Justice Department confiscated a Picasso originally given to the actor by one of the financiers, who laundered more than $400 million stolen from the 1MDB fund. The Picasso in question was originally bought for $3.2 million, with money used from a 1MDB bond sale, and came to DiCaprio with the following note: "Dear Leonardo DiCaprio, Happy belated birthday! This gift is for you." DiCaprio was also given gambling money and other luxuries. He has been very cooperative in handing over the Picasso to authorities. The star of many films including *The Wolf of Wall Street* (partially funded by 1MDB money) hasn't been charged with any crime for accepting those gifts.

Basquiats, Rothkos, Van Goghs, and others, were also bought by Malaysian officials and associates with misappropriated funds from the 1MDB fund. To give you an idea of the scope of the fraud and how affecting it can be in the art market, authorities state that, in 2014, Sotheby's gave a $107 million loan to a Cayman Island company owned by one of the accused launderers in order to sell the paintings at auction.

Fraud like this is possible, in part, when the transparency rules aren't strong enough at art auction houses. A 2015 sale of a Toulouse-Lautrec work, *Au Lit: Le Baiser*, was consigned to Sotheby's by an art dealer with all the signed paperwork that claimed he owned the work. Money from the sale was handed over to the consignee. However, even though the sale was authorized, the real owner of the work (a trust controlled by Russian billionaire Dmitry E. Rybolovlev) complained about Sotheby's lack of thorough fact-checking. This could be problematic in sales that aren't actually authorized. The requests for transparency in big sales are thorough, of course, especially with Christie's and Sotheby's, and purchasers are asked where the money comes from. In a statement made in early 2017, Christie's said "Where

it has concerns, Christie's declines the transaction." The auction house has strengthened its transparency rules further to require disclosure of whom a dealer represents.

Granted, eliminating anonymity is an invasion of privacy. Sellers sell for various reasons: a family trying to avoid debt or a museum trying to covertly unload works from its collection. But for a collector such as myself, I'm definitely in favor of stricter rules for bidders at art auctions, if only to make the bidding field more even. I, for instance, am careful and selective, when bidding, because I'm bidding on works of art with my own hard-earned money. It's frustrating to think I may lose out on a piece I really want because the other bidder isn't bidding with his or her own money. It's easy come and easy go for some of these money launderers and their actions make it harder for true art collectors to acquire pieces they desire in a fair and democratic fashion.

Ebay and the Online Market

As I have talked at length about buying art at Sotheby's and Christie's, I want to talk about buying art online—specifically on eBay, Amazon, Alibaba, and other internet sites, and small auctions. This is a useful guide, not directions on using each platform's tools. Mostly, they are similar to each other and feature bidding or outright buying buttons. Your main approach for buying fine art from eBay should be to buy established artists with recognizable names. You want to buy Old Masters, dead Modern artists, or even the Neo-Pop artists, as long as the works have **proven track records and good documentation**.

You should try to buy originals, but if you're definitely in the market for lithos and etchings, be careful as they can be reproduced and printed with current digital printers. It's often hard to tell the material of the impression, especially with old pieces. Is it an actual etching or a digital printing? The ink may look similar. Also, make sure that the copy is hand-signed and numbered in limited editions. Later Warhol prints, for instance, were printed with modern technology so having an authentic signature makes all the difference.

Most of the big artists keep a catalogue raisonne that lists the detail of every work they ever produced or issued, such as the year, title, technique of manufacture, size of image, size of printed sheet, and the edition amount. As a collector, you can cross-reference the piece you see online to the artist's catalogue raisonne to make sure the piece actually exists and lines up with what's in the artist's catalogue.

I talk about non-authorized works in a previous section but it's important to extract the information on whether the impression of a

litho or etching was authorized during the artist's lifetime or if they were re-strikes or posthumous impressions. The latter has less value. Re-strikes can have a faded quality and are, therefore, less desirable. And posthumous works are less desirable because the artist wasn't there to supervise their manufacture. Plus, posthumous pieces won't have a signature, rightfully so.

Buying an artwork with a certificate of authenticity (COA) is a must. However, it's important to note that a COA is only as valuable as its issuer. Sometimes it's from an appraiser and sometimes it's from the estate. If it's from the estate, the COA might be from a family member. For a unique Picasso piece from the estate, it can only be Maya or Claude Picasso that can authenticate those works (as appointed by the government of France). Works from before 1900 have to be appraised by an authority. Most experts prefer not to authenticate non-originals, as their evaluation might be tricky. A good certificate of authenticity should contain only factual information, not hearsay or inferences as to the piece's history or authenticity.

The pricing online is retail pricing, basically, as if you are walking into an actual gallery. If their works are on consignment, or otherwise, they are sold at a percentage mark-up. If the price seems too good to be true, the piece is a fake or has no validating paperwork. For example, there is no way you can find a signed original Picasso litho for under $5000. Too good to be true. But prices do vary sometimes, from gallery to gallery. A signed litho from a series can be listed for $15,000 by one seller and $30,000 by another. The condition can affect pricing or it is simply competition between galleries. Lithos are printed on a piece of paper that can range from excellent to poor condition. A crease or tear or stain on the paper can make a big difference in the price.

How do you know that the signature is real? For major artists, you can find catalogues of their signatures online or through galleries or authenticating companies. The COA should guarantee the signature and list the artist's date of birth, to validate that it's the same person and not another unrelated person named Picasso (they do exist). Do your own research and due diligence. Don't just depend on the paperwork listed. Make sure that the paperwork is real. Don't be afraid to ask the seller questions. Will the seller guarantee the authenticity of the work for your

lifetime and would they accept a return or exchange? Look for that in the listing. If they don't accept returns or exchanges, I would take that as a bad sign. They might just want to unload a fake or simply don't have faith in what they're selling. That dubiousness adds risk rather than value to your investment.

As mentioned above, quality and condition plays a big role in the price and value of a piece. For prints, aside from creases and tears in the paper, color and centering are also very important. Earlier, clearer impressions can sell for tens of thousands more than later faded impressions. For prints or original paintings, you want to choose the most iconic image by the artist you like (for example, Warhol/Marilyn) and in the best condition, at the best price, with all the paperwork in order. The actual execution of an original artwork is also important. You don't want anything with sloppy lines or brushstrokes or poor color choices. A great question to ask yourself is: Can the artwork grab your attention from across the room? Also, can you tell who it's by? You want a quality work by a quality artist and you want to trust the source.

Of course, Sotheby's and Christie's I recommend the most, since they're most established. Their commission fees may be higher but they have a trusted brand that gives me peace of mind. They also do thorough due diligence. Although some pieces can fall through the cracks, that's not to say you can't find a great buy online.

There are several other auction houses that sell online. There is LiveAuctioneers, Heritage, Phillips de Pury, Bonhams, and Swann, which sell contemporary artworks by some notable artists. Regarding Phillips, because they often deal directly with the artists, as opposed to being a secondary selling facilitator, the works are considered "wet works"—meaning the paint is still wet. About 20 years back, Phillips was unique in that respect but now even Sotheby's and Christie's sell many items directly from the artist's studio. Damien Hirst was one of the first big names to premiere his new series directly through the auction houses, bypassing art dealers/galleries. In fact, in 2008, he had a two-day auction at Sotheby's that surpassed expectations for a living contemporary artist. Now, many big-name artists are taking their works straight to auction houses. So you're more than welcome to try out other auction houses and online auctions but tread carefully. Online buying is

the future. And you never know. If you are smart and lucky, you may get a great work of art for a great price at these other venues.

Conclusion

No home should be without an original work of art. Your surroundings say so much about you and invite others to get to know you in a new light. Collecting is not only natural, but can provide a purpose in life. As small children, haven't all of us collected shells at the seashore, smooth stones, bottle caps, baseball cards, or dolls? As we get older, we don't lose the urge to collect objects of beauty or curiosity. Collecting just matures with us. As a young boy I collected stamps and coins-and I still have them. I was so proud to show them to my grandson Jacob who recently became interested in collecting stamps. Unfortunately, I did not collect baseball cards which have skyrocketed in price in the last decade. We are a collecting species. We are consumers looking for hidden treasures and respond to beauty, creativity, and originality. Put these sensibilities together and you have the makings of an art collector. It is a creative act that brings something new into existence -a sense of uniqueness. It also creates camaraderie and social binding. It is a combination of **work, play, and love** that transforms itself into an elegant way to serve beauty, utility, the self, and others.

Why should you collect? That is a question to answer for yourself. Some people collect art just in the same way that they shop; to fill a void or for recreation. Many relish the bidding process at art auctions, for the sake of competition. Others collect art as a financial investment or with the object of growing a valuable collection that can be left as a legacy (to family, university, or a museum).

I collect because it is exciting. The items that I collect express

CONCLUSION

who I am and my tastes to others. Through art collecting, I also discover things about myself. Artists are thinkers and they transmit high concepts about life, existence, ethics, aesthetics and politics in ways that enlighten the audience. Sometimes, simply, the artworks are great conversation pieces that raise those important topics for discussion.

It is important that you develop a collection that suits your individual tastes. It is vitally important that **you like what you collect**, since it is an expensive hobby and you usually have to live with the art for years before you can expect to make a profit on the sale. Or you may never make a profit and may actually lose money just like investing in some stocks. They do not always go up in value, although the value constantly increases for the majority of the artists I've covered in this book.

I hope you enjoyed our trip through my art collection and my experiences in acquiring works of art. More importantly, I've tried to give you some art collecting insights. Covering as much as I could, I hope my book can serve as a starting point for a novice collector or enlighten those who have already begun their art collecting journey.

From that initial moment, looking up at the art on the walls of the Brooklyn Museum as a small child, to winning those five works of art in my first auction and unveiling them for the first time, it's been a fantastic ride. I learn something new with each piece I purchase. They inspire me to try new things with my sculptures and make me contemplate life and beauty, in all of their forms.

Since I own works that date back to the 16th century, I also learn about world history, not just art history. For instance, religion used to be a lot more influential to artists and their subjects. Now, in our post-modernist era, the focus is the subjective self and how the self fits into the social sphere. A couple of hundred years ago, when realistic art was in favor, artists' techniques and brands were more subtle. Now, each artist seems to be known for "their' thing, especially the abstract artists with hard-edged or drip paintings, Warhol with celebrity paintings, Koons with balloon figures, and Hirst certainly has a few styles in his oeuvre.

It has been a great opportunity to share some of my experiences from art collecting from over the past 40 years, and to share anecdotes

about some of the pieces. I've done a lot of the due diligence for you, such as naming notable artists to invest in. I've also tried to bring in facts and stories from outside my personal collection to liven up the narrative and provide information about artists worth collecting—who's hot or who's not in the art market. It's important to know where and when to buy (like during a recession), not just what to buy.

Additionally, I wish this book to serve as a legacy to my family - a document to the great care that I put into my art collection. I hope that my collection serves as encouragement to embrace your passion for art, as I have. Explore. Take the journey through the minds of great artists. Invest in an artwork today, for both pleasure and profit!

ACKNOWLEDGMENTS

This is book #5. Who do I thank first? I thank all the great artists that made art history possible and the artists in the future that will carry the torch forward. Of course, I give kudos to the people that inspired this book and made important contributions: My daughter Melissa, who gave me the idea to write this book; my family, including Joshua, Wendy, Natasha, and Barbara, who have always been very supportive of my art collecting efforts; and Meryl Feuer who encouraged me on a daily basis to write the manuscript even though I had to lock myself in a private room and ignore her for days and weeks. Also, thanks to my friend and in-law, Dr. Arthur Germain, for his very helpful, somewhat OCD editing, which was sorely needed. A big thanks to Charles Riley (director of the Nassau County Museum of Art), for his intellectual input and editing. And lastly a huge thank you to Cristian Aluas who spent considerable time helping to organize and edit this book.

Index

A

Ab-Ex 45, 47, 48
Abstract-Expressionist 12
Adams 60, 64, 67
aftermarket 99-102
Arbus 67
Archipenko 70-72
avant-garde 92, 132

B

Banksy 54, 125, 126, 137
Barney 63
Basel 81, 112
Basquiat 14, 23, 33, 54, 55, 111, 120-122, 126, 127, 129
Beltracchi 140
Benton 129, 130
Bois 25, 27
Bonhams 10, 146
Botero 72, 73
Brainwash 54, 125, 126
Braque 18, 45, 77, 131
Brueghel 14, 15, 69
Burchfield 30, 31

C

Calder 23, 30-32, 95
Carrington 29, 30
Cattelan's 76
Cezanne 18, 86, 87
Chadwick 71
Chagall 3, 4, 8-10, 12, 18, 25, 26, 57, 138
Chirico 18, 36, 127
Christie's 6, 10, 51, 52, 71, 82, 87-89, 95, 101, 102, 104, 105, 107, 113, 134, 135, 138, 140, 142-144, 146

Christo 66, 75, 77-79
Cubism 18, 25, 45, 56, 72, 77, 131
Cucaro 122

D

Dadaist 29, 76
Dali 18, 27-29, 94, 105, 106, 118, 122, 134-136
Deschamps 135
de St. Phalle 70, 74, 75
Drewe 138, 139
Dubuffet 106
Duchamp 18, 29, 35, 48, 75, 76
Dürer 10, 11

E

eBay 144, 147
Ernst 29, 140
expressionism 18, 25, 33, 41, 48, 56
expressionist 14, 30, 101

F

Fairey 54, 125, 126
Fauvism 18, 25
Fischl 129
Fragonard 3, 64, 65
Francis 15, 47, 68, 69, 100, 101

G

Gagosian 13, 40, 91, 114
Gauguin 18, 86, 87
Giacometti 18, 25, 26, 141
Gogh 18, 117, 120, 132, 139
graffiti 54, 121, 125, 126, 137
Greco 14, 15, 33, 68, 69, 100-102, 129
Greuze 3

H

Haring 33, 54, 55, 120, 121, 126
Hirst 12, 33, 50, 51, 68, 90-92, 94, 118, 132, 146, 149
Huan 132, 133

I

Impressionism 18, 56, 96
Impressionist 1, 6, 9, 16, 18, 96

J

Johns 35, 41, 42, 76

K

Klein 52, 53, 99, 104
Kooning 12, 45, 46, 86, 87, 106
Koons 12, 33, 50-53, 59, 60, 68, 92, 118, 149
Kostabi 127, 129

L

Leger 7, 10, 18, 24, 45, 127, 134, 140
Lichtenstein 12, 33, 34, 36, 38-40, 79, 115, 116, 131
litho 17, 35, 58, 91, 92, 107, 108, 111, 112, 135, 145
lithograph 8, 17, 23, 58
Louvre 53, 89, 92, 93, 137

M

Mapplethorpe 60-62, 116, 121
Marilyn 35, 98, 107, 110, 117, 118, 146
Marsh 130, 131
Michelangelo 14, 43, 53, 140
Miro 9, 18, 23, 96, 107, 134
Modigliani 87, 89
Mondrian 18, 45, 67, 90
Monet 12, 16, 90, 96, 137

Mundi, Salvator 33, 87, 88, 102
Muniz 64, 65
Myatt 138, 139

N

Nevelson 70, 73, 74

O

Obama 126
Oldenburg 34, 37, 70, 102

P

Picasso 7, 8, 10, 12, 18-21, 23, 33, 45, 48, 57-59, 68, 72, 77, 79, 90, 92, 93, 96, 101, 107, 118, 122, 131, 138, 142, 145
Pissarro 16-18, 96, 134
Pistoletto 43, 44
Pollock 12, 45-47, 90, 120, 121, 129
prints 8, 18, 19, 23, 108, 141, 144, 146

R

Rauschenberg 41, 42, 75, 77
Ray's 29
ready-made 48
Rembrandt 10, 12, 14, 15, 33, 82, 83, 118, 132
Rivers 34, 36
Rodin 70, 72, 132
Rosenquist 34, 37
Rossellini 61
Rubin 32
Rybolovlev 88, 142

S

Saatchi 90, 91, 114
Salgado 62, 63
Scharf 54, 55, 111, 125, 126

Schnabel 129
Slonem 33, 127
Sotheby's 6, 9, 10, 13, 25, 42, 82, 89, 95, 96, 104, 107, 110, 113, 122, 134, 138, 140, 142, 144, 146
Soyer 96, 97, 130
Streisand 107, 108
Surrealism 18, 25, 112
Surrealist 27, 29, 30

T

Tansey 46, 47
Toulouse-Lautrec 16-18, 27, 90, 106, 107, 142

V

Valtat 6, 7, 96
Vasarely 45, 48, 49, 95
Vermeer 2, 3
da Vinci 14, 82, 87-89, 93
Vogels 79

W

Warhol 12, 33-36, 43, 54, 55, 76, 98, 107, 110, 117, 120-122, 127, 131, 137, 144, 146, 149
Wesselmann 34, 40, 41, 116

Z

Zwirner 114

Artist or artwork in the book that is not personally owned by Dr. Manes.

In Order of appearance.

Page 2: Mistress and Maid (1668) Vermeer courtesy of the Frick Collection and Woman with Pitcher (1665) Vermeer courtesy of the Metropolitan Museum of Art.

Page 3: Broken Eggs (1756) by Greuze and Young Girl Reading (1776) by Fragonard courtesy of the internet.

Page 31: The Calder "stabile" and "mobile" courtesy of the internet.

Page 46: Jackson Pollock Drip Painting courtesy of the internet.

Page 47: Mark Tansey's The Myth of Depth (1984) courtesy of the internet.

Page 50: The Physical Impossibility of Death... (1991) and For The Love Of God (2007) by Damien Hirst courtesy of the internet.

Page 52: Balloon Dog (2000) by Jeff Koons courtesy of the internet.

Page 67: Kid Holding a Hand Grenade (1962) by Diane Arbus courtesy of the
internet.

Page 76: Fountain (1917) by Marcel Duchamp courtesy of the internet.

Page 87: Interchange by Willem de Kooning, The Card Players by Paul Cezanne,
and When Will You Marry? by Paul Gauguin courtesy of the internet.

Page 88: Before and after restoration of the Salvator Mundi by da Vinci, courtesy of Christie's New York.

Page 89: Nu Couché (Sur Le Côté Gauche) (1917) by Amedeo Modigliani courtesy of the internet.

Page 93: Les Demoiselles d'Avignon by Picasso and Mona Lisa by da Vinci courtesy of MoMA and the Louvre.

Page 94: Photo of Salvador Dali courtesy of the internet.

Page 99: Winged Victory by Yves Klein courtesy of the internet.

Page 120: Irises (1889) by Vincent Van Gogh courtesy of the internet.

Page 137: Photo of Banksy painting hung in museum courtesy of the internet.

Page 139: Oleanders (1988) by John Myatt and Oleanders (1888) by Vincent Van Gogh courtesy of the internet.

-Dr. Harvey Manes

Proceeds from this book will go to the
Manes American Peace Prize Foundation